Acrylics in
10 STEPS

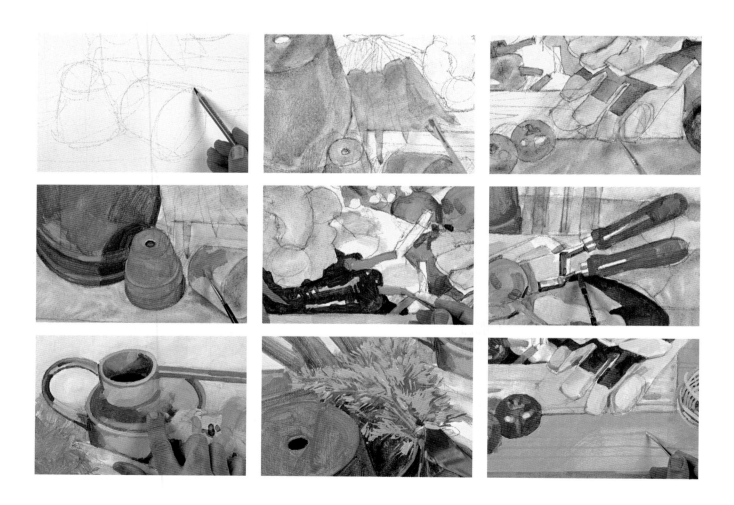

Ian Sidaway

Acrylics in
10 STEPS

Learn all the techniques you need in just one painting

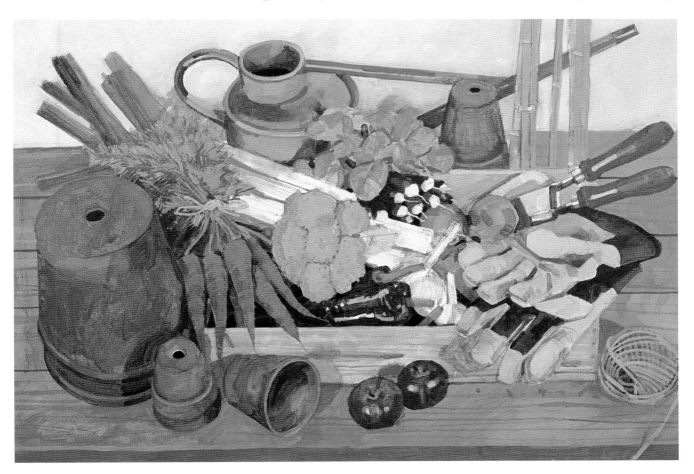

Bounty
Books

First published in Great Britain in 2007 by Hamlyn,
a division of Octopus Publishing Group Ltd

This edition published in 2011 by Bounty Books,
a division of Octopus Publishing Group Ltd
Endeavour House, 189 Shaftesbury Avenue,
London WC2H 8JY
www.octopusbooks.co.uk

An Hachette UK Company
www.hachette.co.uk

ISBN: 978-0-753722-54-1

A CIP catalogue record for this book is available from the British Library

Printed and bound in China

contents

introduction

Major advances in drawing and painting materials are rare; most materials have been with us for hundreds of years.

With the 20th century came numerous technological advances, not least the invention of the synthetic resins that formed the basis for a whole range of 'plastic' products. Among these products were the fluid acrylic emulsions that are soluble in water. These proved to be the perfect binding agent for paint and the first commercially available water-based artists' acrylic paints became available in the 1950s. Since that time manufacturers have improved and updated the quality of the paint and have produced an enormous range of mediums and additives to alter the consistency and finish of the paint and the way in which it can be used and applied.

What excites artists so much about acrylic paint is its incredible versatility. Here is a material that you can use to develop all of those techniques usually associated with oil painting, but that you can also use to achieve a wide range of watercolour techniques. You can mix techniques associated with oils and watercolour in the same painting or use acrylics in mixed-media works along with pastels and a host of drawing materials. Thanks to the adhesive qualities of the acrylic binder and the various painting mediums now available, acrylic paint is also ideal for effects that use collaged materials.

One significant benefit for the artist is that acrylic paint and its additives are all soluble in water when they are wet. This does away with the need for toxic solvents or acrylic painting mediums that take ages to dry, and simplifies cleaning brushes and palettes. Acrylic paint dries very quickly – in a matter of

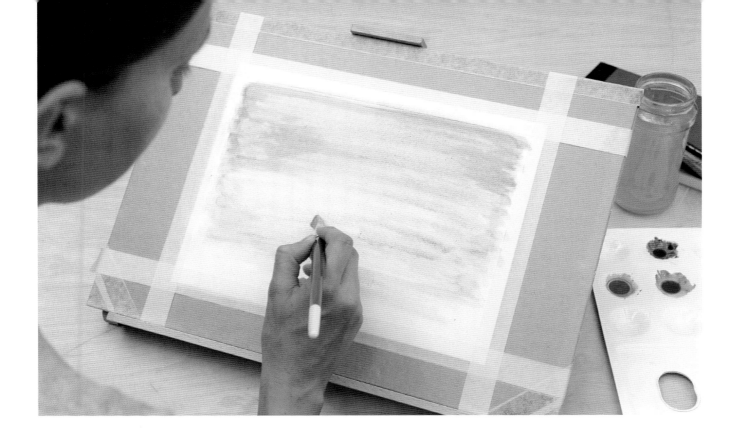

minutes or hours depending on the thickness of the application and the ambient air temperature – and you can use it on any porous surface including paper, card, wood and fabrics, including the traditional supports of canvas and cotton duck.

Demonstrating a number of the qualities unique to this medium, this book offers the perfect introduction to painting with acrylics. Here you will find basic instruction on how to create a range of works, from making the first marks to completing a first painting. Arranged in lesson format, each project of the book focuses on just one aspect of painting with acrylics, be it basic paint application, effective use of colour or establishing the tonal structure of a painting. Once these are mastered, you will learn how to apply the paint using watercolour, glazing and impasto techniques, and how to manipulate the paint by scumbling, spattering and using broken colour. Finally, a close look at composition and three painting projects help you to put your acquired knowledge and skills into practice in creating complete works of your own.

before you begin

choosing the right materials

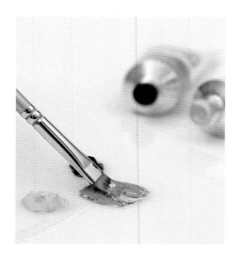

The materials that you need for painting with acrylics are available at most, if not all art stores; they are made by reputable manufacturers and are of good quality. In order to keep initial costs to a minimum, the 'shopping list' below covers just the essentials and those materials necessary for completing the projects in this book. Initially you should buy only what you really need. Further materials may be purchased as and when necessary.

Shopping list

Acrylic paints:

Titanium white

Quinacridone red

Cadmium red medium

Cadmium yellow medium

Lemon yellow

Ultramarine blue

Pthalocyanine blue

Pthalocyanine green

Dioxazine purple

Raw umber

Burnt umber

Yellow ochre

Mars black

Painting surfaces:

25 x 30 cm (10 x 12 in) prepared
 canvas board (x 4)

25 x 40 cm (10 x 14 in) prepared
 canvas board

40 x 50 cm (16 x 20 in) prepared
 canvas board

60 x 75 cm (24 x 30 in) prepared
 canvas board

50 x 60 cm (20 x 24 in) prepared
 canvas board

25 x 30 cm (10 x 12 in) sheet of
 535 gsm (250 lb) NOT surface
 watercolour paper

55 x 75 cm (22 x 30 in) sheet of
 638 gsm (300 lb) NOT surface
 watercolour paper

25 x 30 cm (10 x 12 in) MDF board
 prepared with gesso

Brushes and paint applicators:

12 mm (½ in) flat synthetic-fibre brush

6 mm (¼ in) flat synthetic-fibre brush

3 mm (⅛ in) flat synthetic-fibre brush

18 mm (¾ in) flat bristle brush

12 mm (½ in) flat bristle brush

6 mm (¼ in) flat bristle brush

No. 8 round synthetic-fibre brush

Medium-sized rigger brush

Medium-sized bristle fan blender

Medium-sized watercolour wash brush

Small trowel-shaped painting knife

Spatula-shaped painting knife with
 angled end

Natural sponge

Mediums:

Matte

Gloss

Heavy gel

Texture pastes:

Black lava texture paste

Natural sand texture paste

Miscellaneous:

Hard charcoal pencil

HB graphite pencil

2B graphite pencil

Masking tape

Fixative

Scrap paper

Once purchased your materials should last for a long time if well looked after, and you should need to replace paint and mediums only as they are used. It is important to know that acrylic paint dries very quickly when exposed to air, so be fastidious about replacing tube and bottle caps and tops, and in cleaning brushes and other tools. If you ignore this advice your paint and brushes will very quickly become unusable. Your most regular purchase will be a surface on which to paint and here, as with many things, you get what you pay for.

ACRYLIC PAINT

Acrylic paint is made by suspending a pigment in what is known as an 'acrylic polymer emulsion' – a milky solution that dries clear and is soluble in water – and is applied to a surface mixed with water. As the water content evaporates, the emulsion binder dries relatively quickly to form a flexible and permanent clear film, which holds the pigment onto the support. Once dry, the paint is permanent and cannot be moved.

Acrylic paint is available in several different degrees of thickness or viscosity. High-viscosity paint is relatively fluid and usually comes in bottles, medium-viscosity paint is stiffer and usually comes in tubes, while heavy-bodied acrylic paint is thicker still and usually comes in jars or tubs. You should select the type or viscosity according to the type of work you are doing, although the consistency of each can be altered using additives and all paint can be thinned further simply by adding water.

Paint is usually classified as either 'student' or 'artist' quality – the latter being more expensive than the former. This is because the pigments used are invariably more expensive, more pure pigment is used in their manufacture, and there is a greater choice of colour. The two can be mixed together, however, as can acrylic paint from different manufacturers.

Paint tubes carry useful information, including the name of the paint colour and the pigment type used (usually signified by a name and a code, which is universal and used by all major manufacturers). The degree of light-fastness – that is, the extent to which the paint remains unaffected by light – may also be mentioned, along with the relative opacity or transparency of the colour. In order to create clean, bright mixes try, whenever possible, to use colours that have been made using a single pigment: the more pigments that are mixed together the less pure the resulting colours will become.

Acrylic paint dries quickly so it is best to put out only the colours you intend to use immediately, in quantities you know you will use: you can always add more! The milky appearance of wet acrylic paint often means that the colours look paler than the intended colour once dry and translucent. Although slight, this colour shift can be off-putting, but it will not be long before you learn how to mix your colours accordingly.

PALETTE COLOURS

It makes neither financial nor practical sense to buy too many different colours. In theory, it is possible to mix every colour you could ever need from three carefully chosen primary colours (see Step 2, pages 30–37). Most artists, however, work with a relatively limited palette of between 10 to 16 different colours, from which they have learnt to mix all of the colours that they need.

Our 'beginner's palette' consists of twelve single-pigment colours, plus white. The names of the colours may vary according to manufacturer, so the list below includes the relevant pigment codes in order to make finding the exact hues easier.

A BEGINNER'S PALETTE

Titanium white: PW6
A clean, bright, relatively opaque white with good tinting strength.

Quinacridone red: PV19
A strong, cool red with a high tinting strength. Relatively transparent. Mixes well with yellows to create bright oranges and with blues for intense violets. This colour can be found under various names including quinacridone magenta. It is the ideal primary red.

Cadmium red medium: PR108
A warm red with good tinting strength and opacity.

Cadmium yellow medium: PY35
An opaque yellow with good tinting strength, which creates a strong orange colour when mixed with red.

Lemon yellow: PY3
A bright, cool yellow that is transparent. Mixes well with blues to create bright greens. This colour can be found under various names including primary yellow, hansa yellow and cadmium lemon.

Ultramarine blue: PB29
A warm, strong blue with a good tinting strength.

Pthalocyanine blue: PB15
A cool, transparent blue with a very high tinting strength. Can be overpowering, so use with care. Creates very strong violets when mixed with reds.

Pthalocyanine green: PG36
A transparent cool green that has a very strong tinting strength, so use with care. Available in various shades, here we use the yellow shade.

Dioxazine purple: PV23

A bright, transparent purple that mixes very well with other colours. Good tinting strength.

Raw umber: PBr7

A transparent brown with modest tinting strength. Excellent for modifying other colours.

Burnt umber: PBr7

A warm, semi-transparent red-brown with good tinting strength.

Yellow ochre: PY43

A relatively transparent earth colour made from natural hydrated iron oxide. Good for modifying other colours. The synthetic version is yellow oxide (PY42).

Mars black: PBk11

A dense, neutral black that is opaque.

PAINTING MEDIUMS AND ADDITIVES

There are countless painting mediums and additives available for altering the appearance of acrylic paint, or the way in which it behaves. Although acrylic paint can be used just with water, the true potential of the material can only be fully exploited by using such mediums. Whatever the effect you would like to create, there is doubtless a medium that will enable you to do it; some mediums are iridescent, can make the paint shimmer and sparkle, or resemble gold, silver and copper; some additives bulk out the paint and set it rock hard so that it can be sanded or carved into shape. The possibilities are plenty. For the purposes of this book, however, the mediums and additives listed suit more conventional applications.

The two most commonly used painting mediums are 'matte' and 'gloss', both of which you add to the paint as you work. They are slightly milky and fluid in appearance but dry clear. As their names suggest, matte medium dries to leave a matte finish while gloss medium imparts a gloss finish to the dry paint. The two can be mixed together to produce a finish with varying degrees of sheen. Gloss medium increases the transparency and intensity of the colours and some gloss mediums can be used as a final varnish.

Thicker versions of each type are available and add body to the paint, making them an ideal choice for impasto work (see Step 5, pages 54–61). The addition of these 'gel' mediums also increases the transparency of the paint. In order to bulk out the paint without affecting its opacity use an additive known as an 'extender': this does not affect the colour but does increase the volume of the paint. If you are using large quantities of expensive paint adding an extender to the mixes can cut costs.

Acrylic paint dries relatively quickly, which can cause problems when working 'wet into wet' or blending large areas of colour (see Step 3, pages 38–45). 'Retarding' mediums prolong the drying time of the paint and keep it workable for much longer. 'Glazing' mediums increase the transparency of the paint and prolong the drying time slightly to enable the smooth application of flat glazes. 'Flow improvers' reduce the surface tension of paint that is very liquid, making it easier to brush out and prevent beading and puddling on the paint surface. Added to thicker paint, it will reduce the appearance of any brushstrokes. Always follow the manufacturer's instructions for quantities and mixing.

Painting medium: Mix acrylic painting medium into your paint, along with water, until you achieve the desired consistency for the work you intend to do.

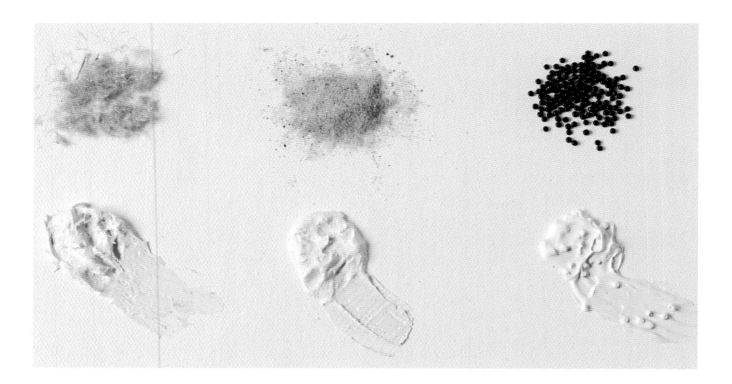

TEXTURE PASTES

For many years, artists have added sand, plaster or sawdust to oil paint in order to give it bulk and a physical texture. Along similar lines, manufacturers of acrylic paints produce a relatively large selection of texture pastes that hold various types of aggregate in an acrylic gel. You can apply them in a raw state and paint over once dry, or you can mix them with paint prior to application. The various ingredients include tiny glass beads, pumice, soft fibres and natural or resin sand. The pastes can very easily ruin your brushes so use old brushes or painting knives and clean all utensils thoroughly before the paste dries.

You can create your own texture pastes by adding various aggregates – hemp fibre, sand or beads – to a gel medium.

GESSO AND VARNISH

You can use acrylic paint on any suitable surface without prior preparation. If you wish, you can seal the surface by applying a coat of matte painting medium diluted with water. Alternatively, acrylic gesso primer provides a brilliant white surface on which to work. Coloured gesso is also available, or you can colour your own simply by mixing gesso with acrylic paint. Once a painting is finished and dry, you may wish to apply a coat of protective varnish. Gloss, matte and satin variations are available and can be mixed to create the desired surface finish.

BRUSHES, PAINTING KNIVES AND OTHER APPLICATORS

Any kind of brush can be used with acrylic paint: the choice depends entirely on the type of painting – or the technique used – and the intended effect. Whatever type of brush you use, be fastidious about cleaning it with soap and water once you have finished work and never allow paint to harden on the brush. Avoid leaving brushes resting on their bristles or fibres in water for long periods of time: it is far better to rest them in a tray of water with just the bristles or fibres and part of the ferrule submerged.

The many shapes of brush fall into one of four different categories: round, flat, filbert and fan. Round brushes can be long or short with the brush fibres finishing in either a pointed or domed shape. The former are often used for detail and more precise work while the latter are more useful for underpainting (see Step 4, pages 46–53). Long round brushes are also known as rigger brushes.

Flat paintbrushes can be short or long in length and up to several centimetres (inches) wide. They deliver a precise stroke and, depending on their size, are used for creating precise considered detail, for flat applications of paint, or for fluid, flowing, expressionistic effects made with thick paint. The filbert is a flat brush with slightly more depth to the body and a curved or domed end. Available in many different sizes it is an adaptable brush best used for expressive, loose work rather than precise detail. The fan was invented for blending and is a very useful brush for creating numerous effects, especially when painting landscapes.

Brushes are either made from natural hair, bristle or synthetic fibre. Natural soft-fibre brushes, such as sable and squirrel, are traditionally used for watercolours and oil painting. They can also be used with acrylics, but synthetic-fibre brushes are just as good and cost less. Bristle brushes, the mainstay of oil painting, are perfect for use with acrylics. Superior brands have bristles that are slightly split at the end. Known as a 'flag', this device helps the brush hold a larger quantity of paint. Synthetic-fibre brushes have improved greatly over the years and come in all types and sizes. They hold the paint well, are resilient and easy to clean.

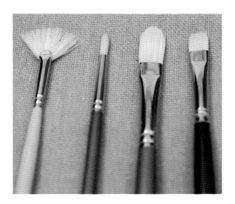

Brushes, from left to right: Fan blender, round brush, filbert brush and flat brush. Each is available with natural-bristle or synthetic-fibre hairs.

You can apply thick paint using a painting knife. These are available in various shapes and sizes, usually made from flexible stainless steel (although a very limited range are made from plastic and are ideal for practising with). Each knife is capable of making a range of marks, and you will need several different shapes and sizes to realize their full potential. The blade is connected to the handle by a cranked steel rod, which allows your fingers to stay free of the paint surface when applying the paint. Palette knives can also be used to apply paint and come both with and without the cranked blade. They are primarily used for mixing paint or cleaning paint from the palette.

A relatively new addition to the world of applicators is the paint or colour shaper. These resemble traditional brushes in shape but have a flexible silicone rubber tip, instead of bristles, that manipulates the paint on and around the support. The range of different tips include round, flat, pointed and chisel shapes and are available in a range of sizes, each with a choice of soft or stiff rubber. Shapers are usually used in conjunction with brushes or painting knives and add an interesting range of marks to an artist's mark-making repertoire. An added advantage of shapers is that they are also very easy to clean after use.

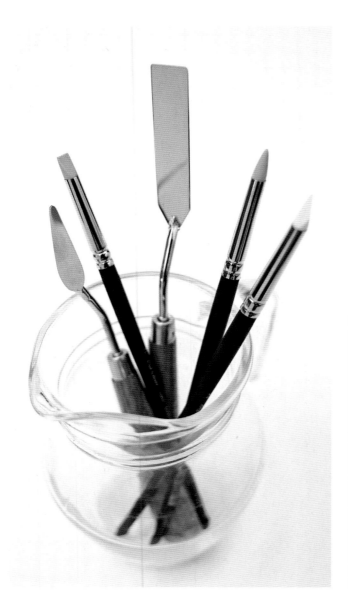

Additional applicators: You can vary your mark-making repertoire substantially by using any from a wide range of palette or painting knives and paint shapers.

Using found objects

Acrylic paint can be applied using almost anything to hand. You can use natural and man-made sponges to render a range of wonderful effects, or experiment with cotton wool buds, cocktail sticks, bits of broken wood, foam rollers, wallpaper strippers and filling knives, broken combs or adhesive spreaders. Look around you and you will find any number of things that can be used to achieve an interesting effect.

PALETTES

Paint is laid out and mixed on, or in, a palette. The type of palette you use will depend on the consistency of your paint. If it is reasonably thick you can use a flat-surfaced palette, but if you intend to use the paint in a very fluid state, as for a watercolour, a palette with wells or reservoirs would be more suitable. The main requirement when working with acrylic paint is that it should not adhere permanently to the surface of your palette. This means using one made from an impervious material such as plastic, formica, ceramic, metal or glass. 'Disposable' palettes, which are thrown away after a work session, are also available and consist of a pad of non-porous paper on which you lay out and mix the paint. At the end of a work session, or once the sheet is full, you tear it from the pad as you would a sheet of paper from a sketchbook and throw it away. A clean sheet is revealed ready for the next session.

Unused paint needs to be cleaned from your palette after each work session and this can be wasteful, because it is very easy to put out more paint than you need. The answer is to use a 'stay-wet' palette. This consists of a shallow tray into which you pour a little water and place a sheet of absorbent paper. You then lay a sheet of semi-permeable paper over the top of the absorbent paper, and the paint on top of that.

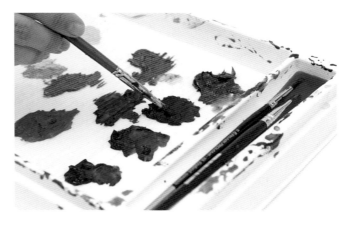

Palettes: The 'stay-wet' palette allows you to keep colour mixes in a fluid state for a number of days.

This arrangement allows the moisture from the absorbent paper to keep the paint moist for longer. Once a work session is complete, a lid fits over the whole tray, keeping the paint workable for several days. It is very easy to make a stay-wet palette using a shallow baking tray, a sheet of blotting paper to act as the reservoir for the water and a sheet of tracing paper on which the paint is mixed. Between sessions, seal the baking tray in plastic food wrap. Whatever type of palette you choose make sure that it is large enough as the palette surface will quickly fill with paint mixes. You will find that you constantly need containers for mixing paint in or on and for holding water. Collect and use old yoghurt pots, plastic cups, tins and fast-food cartons. Old ceramic plates make excellent palettes as do paper plates, which can be thrown away after use.

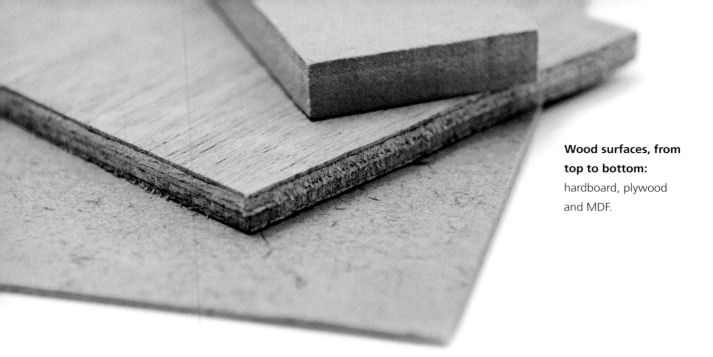

PAINT SURFACES

The surface upon which you paint is known as the 'support' and acrylic paint can be used on any surface that is permeable and non-greasy. This means that there is an extremely wide choice of surfaces, including all those traditionally used for oil and watercolour painting.

You can use any type of paper or card without preparation; alternatively you can seal either using a matte painting medium or prime them using an acrylic gesso. Paper intended for watercolour painting is resilient and makes an excellent choice. There are three options: rough, which is self explanatory; hot-pressed, which is smooth; and NOT, which stands for 'not hot-pressed' and gives a surface that provides a modest degree of texture.

Wooden panels are resilient and, if modest in size, easy to transport. Hardboard, plywood and medium density fibreboard (MDF) are all suitable, with MDF being the most adaptable. It has a smooth surface and can be used sealed with painting medium or primed with gesso. You can buy MDF boards in various sizes or as a large sheet that you can cut to size. Various thicknesses of board are available – the thinner ones being extremely light and ideal for working with on location. You can give all wooden panels a textured surface by mixing texture paste into the gesso primer or by attaching a lightweight canvas or cotton duck (see below) to the surface using painting medium, a technique known as marouflaging.

The two traditional fabrics used for painting are linen canvas and cotton, known as 'cotton duck'. Both are available in a range of weights with the surface tooth, or texture, more pronounced in the heavier weight range. Linen canvas is usually light brown in

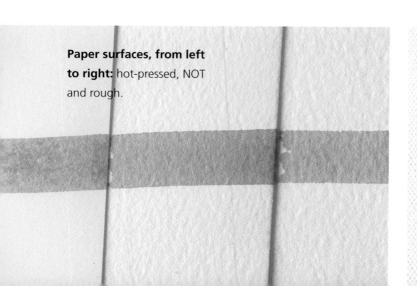

Paper surfaces, from left to right: hot-pressed, NOT and rough.

Canvases, from left to right: canvas, canvas paper, canvas board, acrylic painting paper.

colour while cotton duck is light cream. The advantages in using a fabric surface are that it provides a very pleasing surface to work on and that even large formats are relatively light in weight. As with other supports, you can seal both with painting medium or prime either using gesso.

You can buy canvas and cotton duck surfaces ready prepared in a wide range of sizes. Alternatively you can purchase lengths of canvas and stretcher bars and stretch and prepare your own. The range of prepared canvas is so large that it really only makes sense to prepare your own if you need a size or format that you cannot buy 'off the shelf'. All of the canvas projects in this book use prepared canvas boards.

ADDITIONAL EQUIPMENT

Once you gain confidence in painting, it is worth investing in a drawing board and an easel. The drawing board offers a solid base on which to secure your paint surface as you work and, if you do not yet have an easel, can be propped up at an angle simply by raising one end on books or bricks.

There are many different types of easel, many of which are free-standing, while others sit on a table. The most important consideration when buying one is whether you intend to work primarily on location or in the studio. For location work you will need an easel that you can fold up and transport, while for studio work you could choose a larger non-portable studio easel. Many artists have both.

Portable easels are made from either wood or metal and have 'telescopic' legs, which enable you to use them on uneven surfaces and make them easily transportable. One of the very best portable easels is the 'box' easel. This has adjustable legs and can hold various sizes of paint surface. There is then a box attachment, which holds palette, paint and brushes. The whole thing folds up to the size of a briefcase and has a handle for carrying.

Studio easels are either based on an A- or H-frame – the latter being the largest. These can hold very large supports and have an adjustable height system. They are mounted on wheels so that they can be moved easily. Studio easels can be very expensive but will provide a lifetime of use. Whichever easel you choose make sure it is stable before starting any work: there is nothing quite as frustrating as an easel that collapses at the first sign of a breeze!

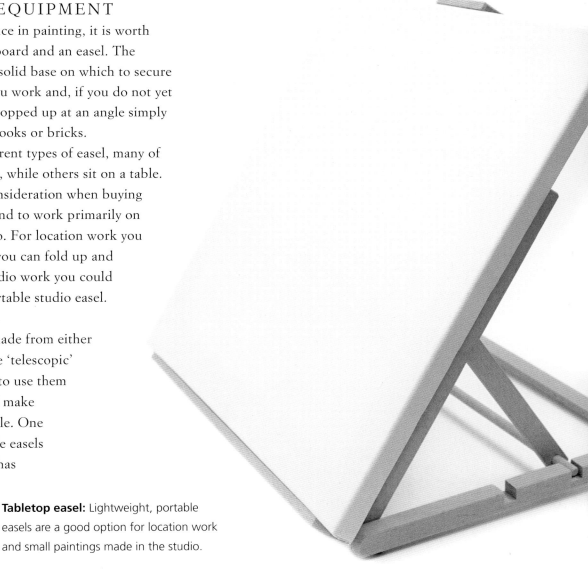

Tabletop easel: Lightweight, portable easels are a good option for location work and small paintings made in the studio.

Step 1
basic paint application

focus: red peppers

Materials

25 x 30 cm (10 x 12 in) prepared
 canvas board

Hard charcoal pencil

Fixative

Matte acrylic painting medium

6 mm (¼ in) flat bristle brush

18 mm (¾ in) flat bristle brush

6 mm (¼ in) flat synthetic-fibre brush

The palette:

- *Titanium white*
- *Quinacridone red*
- *Cadmium red medium*
- *Cadmium yellow medium*
- *Lemon yellow*
- *Pthalocyanine green*
- *Dioxazine purple*
- *Raw umber*
- *Yellow ochre*
- *Mars black*

The fast-drying nature of acrylic paint makes it possible to create an image using several layers in one extended work session. The paint dries and hardens as the water content evaporates and the quality of the painted surface always remains sound.

ADDING PAINTING MEDIUMS

You can use acrylic paint straight from the tube, thinning it to the desired consistency using only clean water. However, most artists tend to work with an acrylic painting medium as well as water (see Painting mediums and additives, page 13). Available in either matte or gloss you can add them either separately or together to produce varying degrees of sheen. The main difference between the two is that using gloss medium increases the transparency of the paint and, owing to its reflective qualities, tends to make colours appear brighter.

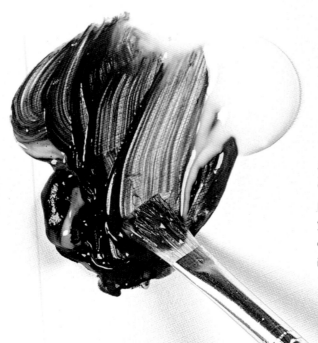

Adding painting medium: Add gloss or matte painting medium to acrylic paint at the mixing stage. The amount you add depends on the desired consistency of the paint and the intended depth of colour.

Gloss painting medium: This imparts a gloss finish to the dry paint (left) while matte medium imparts a matte finish (right).

well diluted with water and painting medium. Once the underpainting is dry, which happens very quickly, you can apply subsequent layers – as many as you wish and using thicker, more opaque, applications of paint – to build up the composition.

One of the very first things that you may notice when using acrylic paint is the slight shift in tone and colour as the paint dries. This happens because acrylic medium has a slightly milky colour when wet, which makes the paint colour appear lighter than it really is. As it dries, the acrylic painting medium becomes clear, allowing the true colour of the mix to show. This is particularly noticeable in light to mid-tone colours.

ACHIEVING DEPTH OF COLOUR

All acrylic colours are recognized as being intrinsically transparent, translucent or opaque. However, even those colours that are labelled opaque are not completely so, and you may need to apply several layers of a colour in order to achieve total coverage. This is particularly the case when using dark colours over light. Depth of colour is usually achieved by working in layers, often on a coloured, mid-toned ground known as an 'imprimatura'. The first layer broadly establishes the overall composition and provides a firm foundation upon which to develop the painting. The paint used in this 'underpainting' is invariably reasonably 'thin' and

WORKING EFFECTIVELY

The relatively fast drying time of acrylic paint is of huge benefit to the artist, however it also has its drawbacks. While it may only be a matter of minutes before you can paint over a newly painted area, this also means that you have a very limited amount of time in which to manipulate the paint should you wish to. This rapid drying time also affects the paint waiting to be used on the palette and any paint left on brushes. One way to keep the paint on the palette workable is to spray it once in a while with clean water, while you should always keep brushes in water. You may also wish to consider mixing a retarding or slow-dry medium with your paint. These slow down the drying time of the paint and enable you to blend and manipulate it for much longer.

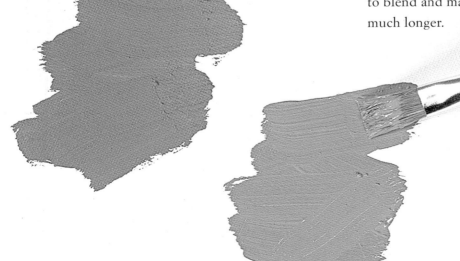

Shifts in tone and colour: You need to adapt to the fact that a paint mix is slightly darker when dry (left) than wet (right). If you are unsure you can always test your mixes on a sheet of scrap paper, checking the colour and tone of each before applying them to your painting.

PAINTING THE RED PEPPERS

In this exercise you learn how to mix acrylic paint with water and a painting medium. You will discover how to achieve the desired paint consistency and will begin to learn how to compensate for the slight colour shift that occurs when the paint dries. The exercise also demonstrates how little colour you need to add in order to change the colour of a mix, how the paint handles, and how it brushes out onto the paint surface.

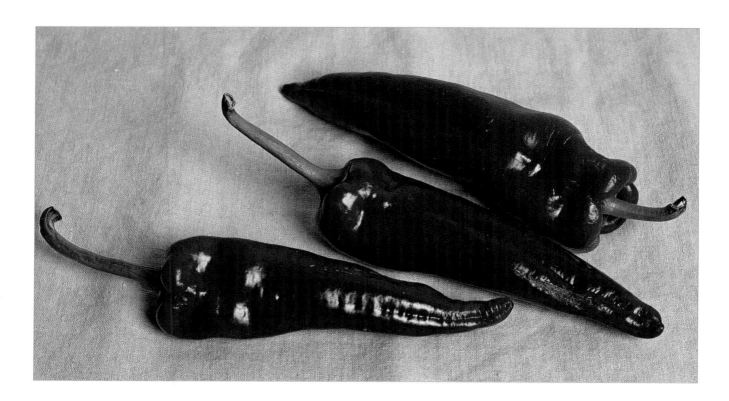

1 Sketch in the position of the three peppers using the charcoal pencil. Begin with basic shapes and elaborate once you are happy with the composition. Apply a coat of fixative to prevent the charcoal mixing with the initial thin layers of paint.

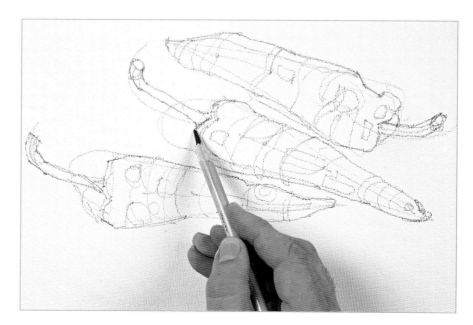

2 Add water and painting medium to your paint mixes throughout this exercise. Mix cadmium red with a little cadmium yellow and use the 6 mm (¼ in) flat bristle brush to block in the lighter areas of colour, avoiding the main highlights at this stage.

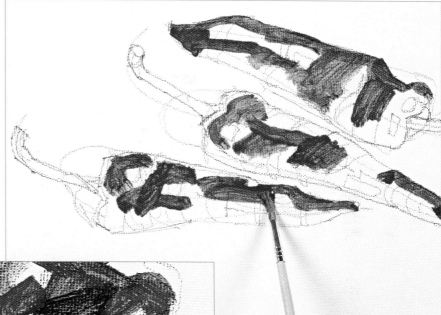

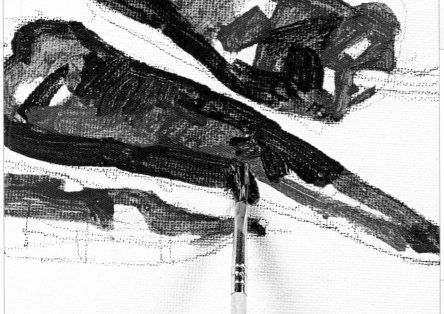

3 Mix an intense red using cadmium red and quinacridone red and use this, together with the previous mix, to establish the main shape and overall colour of each of the peppers.

4 Combine lemon yellow and pthalocyanine green to produce a light green for the pepper stalks. (Take great care when using pthalocyanine green: it is an incredibly strong pigment and can easily overpower your mixes.)

5 Establish the shadow area beneath each pepper using a dark brown made by mixing together raw umber with a little yellow ochre and a little dioxazine purple.

6 Now paint in the background. Mix a light ochre colour using plenty of titanium white with a little yellow ochre and raw umber and apply using the 18 mm (¾ in) bristle brush. As you work use the paint to redraw the shape of each pepper if required. All areas of the painting have now received a first layer of colour.

7 Your work from here will be more considered, and the brushwork more precise, as you focus more accurately on the colours and tones of the peppers. Begin by creating a light orange using cadmium red, cadmium yellow and a little titanium white. Use the 6 mm (¼ in) synthetic-fibre brush to apply this colour to those areas where reflected colour has lightened the red of the pepper skin.

8 Now turn your attention to the range of red mid tones that describe the uneven shape of each pepper. Mix these from quinacridone red, cadmium red, cadmium yellow and dioxazine purple.

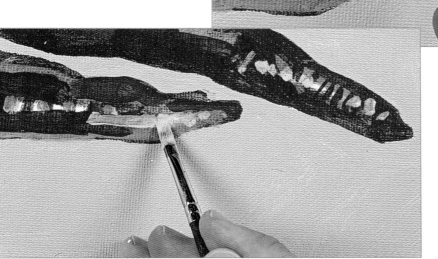

9 Add the highlights by painting a few dabs of titanium white onto the still-wet surface of each pepper.

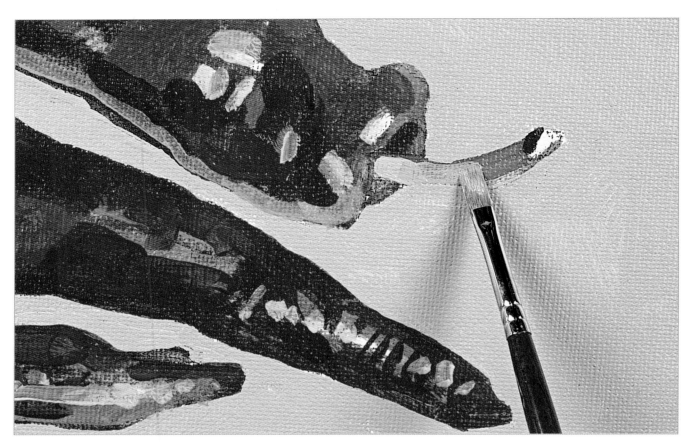

10 Now repaint the green stems. Start with a light-green mix made from pthalocyanine green and cadmium yellow. Subdue or lighten this by adding yellow ochre and titanium white to create a range of greens to match those on each stem. Add a little dioxazine purple to the same mix for the darker tones.

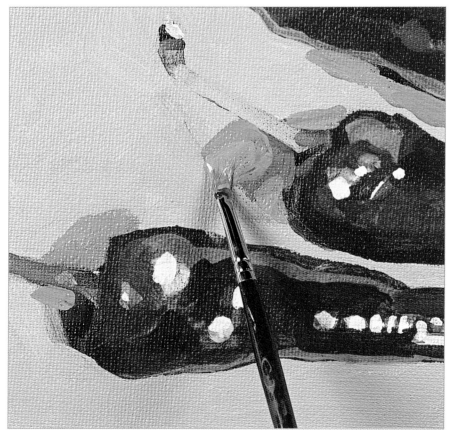

11 Rework the background. Begin by repainting and softening the shadows using a dark beige mix made from raw umber, dioxazine purple, a little mars black and titanium white. Leave the dark underpainting to show through to represent the very darkest area of shadow.

12 Remix the background colour by adding titanium white to what is left of the shadow colour and, using the 18 mm (¾ in) bristle brush, make multi-directional strokes to repaint the background. Work the colour into the still-wet shadows to soften their edges.

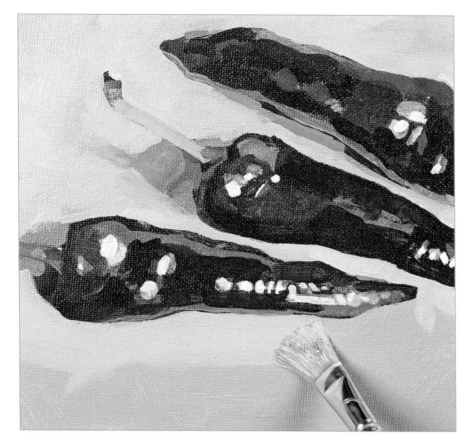

13 In completing this exercise, you will now know a little about paint handling and mixing to the right consistency by adding water and painting medium. You will also have learnt how to build up depth of colour and tone by working in layers.

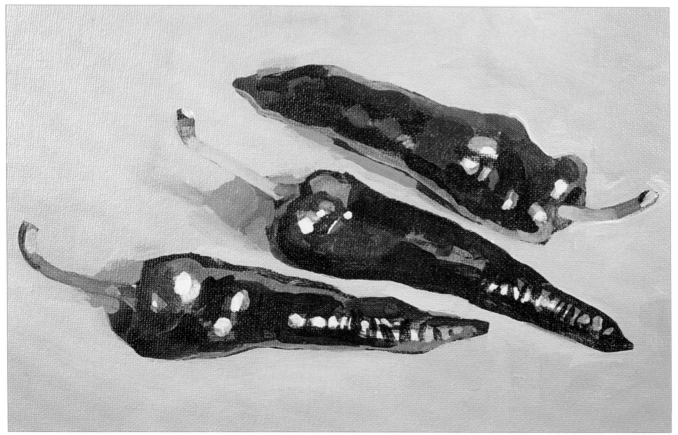

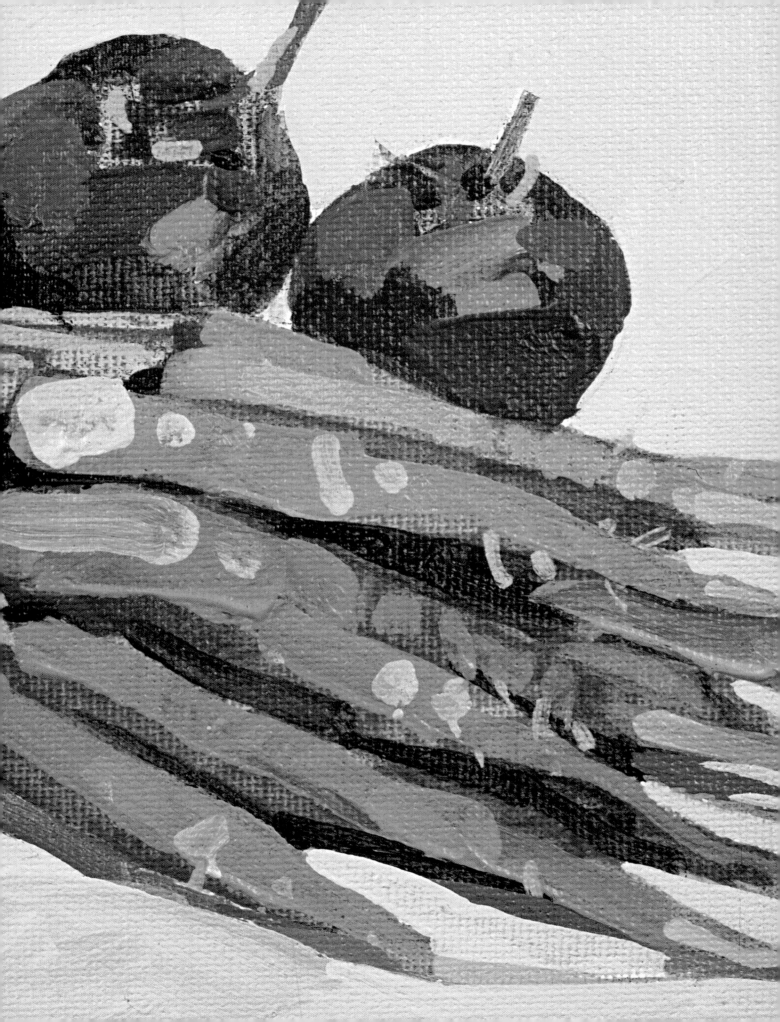

Step 2
colour

focus: carrots, garlic and tomatoes

Materials

25 x 30 cm (10 x 12 in) prepared
 canvas board

Hard charcoal pencil

Fixative

Matte acrylic painting medium

6 mm (¼ in) flat synthetic-fibre brush

12 mm (½ in) flat synthetic-fibre brush

The palette:

- *Titanium white*
- *Quinacridone red*
- *Lemon yellow*
- *Pthalocyanine blue*

With a little practice, you can use the paints selected for the beginner's palette (see Palette colours, pages 12–13) to mix every colour you will ever need. In fact, it is quite possible to produce close approximations of most colours by using just three carefully chosen primary colours plus white.

WHAT IS COLOUR?

Light is made up of a form of electromagnetic radiation of varying wavelengths creating a visible spectrum of colours: red, orange, yellow, green, blue, indigo (or red-violet) and violet. We see a given object as red – say an apple – because all of the coloured wavelengths are absorbed, except red, which is reflected for us to see. When all of these wavelengths are added together the result is white. This is known as additive colour mixing.

Pigment colour behaves differently. Each time one colour is added to another, the colour intensity is reduced, and if all of the primary colours – or mixes made from them – are added together, the result is black. This is known as subtractive colour mixing because the more colours that are mixed together the more wavelengths are absorbed and the fewer reflected. For this reason, in order to keep colour mixes as pure and bright as possible, artists use a range of colours that have each been made using a single pigment.

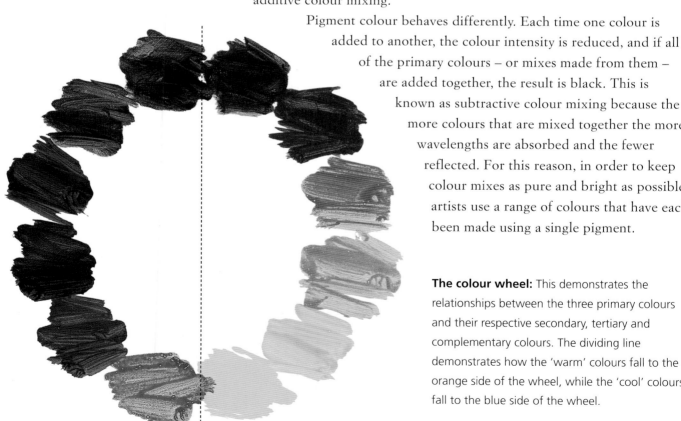

The colour wheel: This demonstrates the relationships between the three primary colours and their respective secondary, tertiary and complementary colours. The dividing line demonstrates how the 'warm' colours fall to the orange side of the wheel, while the 'cool' colours fall to the blue side of the wheel.

Simultaneous contrast (left): Using two complementary colours beside one another, as here with red and green, is known as simultaneous contrast and can often be used to good effect.

Neutralizing effects (right): Mixing two complementary colours together always results in a grey or a brown.

BASIC COLOUR THEORY

The three primary colours are red, yellow and blue. They cannot be mixed from other colours, but have to be manufactured using pure pigments. If you mix red and yellow the result is orange; yellow and blue make green; and blue and red make violet. The resulting colours are known as secondary colours. Combine a primary colour (red) with a secondary colour (orange) in equal parts, and the result is a tertiary colour – in this case red-orange.

The quality and intensity of secondary and tertiary mixes depend very much on those of the primary colours used to create them. There are several red, yellow and blue primary hues to choose from, and the secondary and tertiary mixes made from a combination of any three will be very different. Furthermore, every time you add two colours together, the resulting mix will always be less intense than the two colours used to create it.

Those colours that fall opposite one another on the colour wheel (see opposite) are known as complementary colours, because they complement one another and look brighter and more intense when placed close together. Mixing two complementary colours together produces a neutral colour because, in effect, you are combining three primary colours. Such mixes are very important, as they are similar to many of the colours seen in real life. By adding white you can produce a full range of greys and browns, and by carefully mixing all three primaries together in almost equal measures, you can make a good black.

COLOUR 'TEMPERATURE'

All colours are described as being either 'warm' or 'cool': the warm colours fall on one side of the colour wheel and the cool colours on the other (see opposite). However, colour temperature is slightly more complex in that each colour has a warm or cool variant depending on its colour bias: for example, cadmium red is considered a warm red because it leans towards yellow. In order to mix a full range of colours, therefore, you need a suitable warm and cool variant of each primary.

Over the years, manufacturers have developed almost perfect primary hues that are neither warm nor cool in bias and so are capable of mixing a full range of brilliant secondary and tertiary colours. These three hues are included in the basic palette.

Cool and warm primaries: These examples of the three primary colours demonstrate how each has variants that are considered cool (top) and warm (bottom).

PAINTING THE CARROTS, GARLIC AND TOMATOES

The purpose of this project is to practise colour mixing using three near-perfect primaries and white. In theory, it is possible to mix most colours from just these four. Working with them is a discipline that will teach you much about colour mixing. You will notice how a very small amount of added colour can alter a mix significantly, and you will learn how to mix neutral colours using complementary colour mixes.

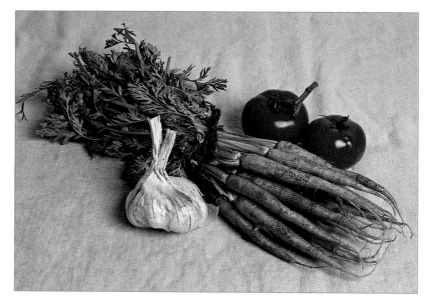

1 This composition is set on a diagonal axis. Sketch in the various components using the charcoal pencil and give the drawing a coat of fixative to prevent the charcoal dust mixing with the initial layer of paint.

2 Add water and painting medium to your paint mixes throughout this exercise. Create a bright red by mixing quinacridone red with a little lemon yellow and apply, using the 6 mm (¼ in) brush, to block in the shapes of the two tomatoes. Add more lemon yellow to the mixture and use to establish the overall colour of the bunch of carrots.

3 Mix a bright, mid-green for the carrot leaves using pthalocyanine blue and lemon yellow. This will be very bright, so subdue it with a little quinacridone red. Add more quinacridone red to subdue the green mix further for darker leaves and the two tomato stalks.

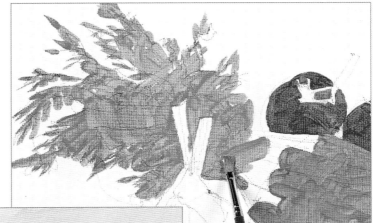

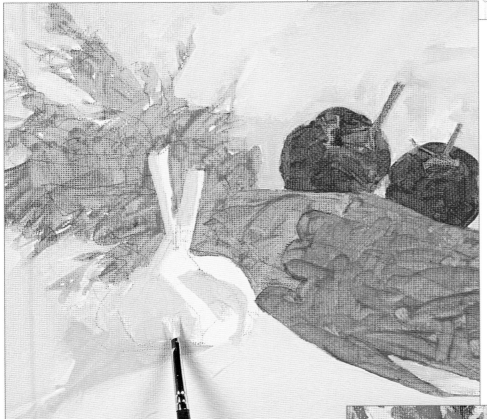

4 Mix varying quantities of the three primary colours to make a neutral brown. You may need to experiment a little before achieving the desired colour. Add a little of this brown to titanium white to create a light beige for the background colour. Apply using the 12 mm (½ in) brush, and the 6 mm (¼ in) brush in confined areas. Darken this mix with a little more of the original brown and return to the 6 mm (¼ in) brush to establish the mid tones on the bulb of garlic.

5 Now create as near a black as you can by mixing quantities of the three primary colours together. To do this, you will need to add a tiny amount of each colour at a time until the balance is right. Mix a deep green using pthalocyanine blue and lemon yellow and add a little of your mixed black to create a dark green. Use this to paint in the darks deep within the recesses of the carrot leaves. Mix a mid-green (see step 3), add titanium white and rework the mid tones on the leaves.

6 Mix a range of reds using quinacridone red and the lemon yellow, varying the tone of each by adding a little mixed black or titanium white, and use these colours to repaint the tomatoes using the 6 mm (¼ in) brush and directional strokes.

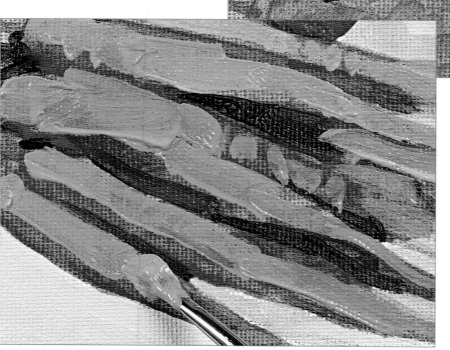

7 Mix a bright orange from lemon yellow and quinacridone red. Use a little of this and the mixed black to create a deep brown for the shadows between the carrots. Add titanium white to the bright-orange mix to subdue the intensity of its colour and make it lighter. Use this to repaint the top of each carrot where it catches the light.

8 Mix a range of light greys and browns using all three primaries. Again, you may need to experiment with quantities to achieve the right mixes. Add titanium white to lighten the mixes and alter the tones for the garlic bulb. Use the same basic neutral mixes to block in the shadows around and beneath the vegetables.

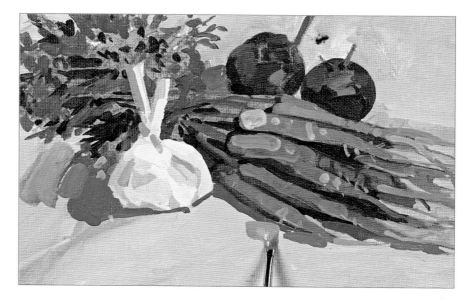

9 Mix a fresh quantity of the background colour (see step 4) and repaint, carefully working up to, and around, each vegetable, redrawing and redefining the shapes as you work. Use multi-directional strokes across the area using the 12 mm (½ in) brush, and the 6 mm (¼ in) brush in confined areas.

10 Complete the form and detail of the foliage of the carrots. Mix a bright green using pthalocyanine blue and lemon yellow and add plenty of titanium white to subdue but lighten the colour. Use the 6 mm (¼ in) brush to flick in small dabs or fine lines of colour to suggest the stalks and fringed edges of the leaves.

11 In completing this exercise, you can see just how much can be achieved with only three colours and white. You will have practised your colour mixing and learnt much about colour by putting the theory into practice.

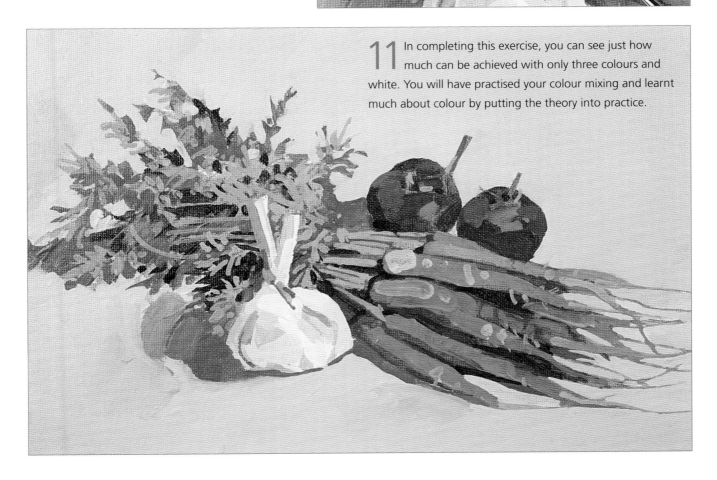

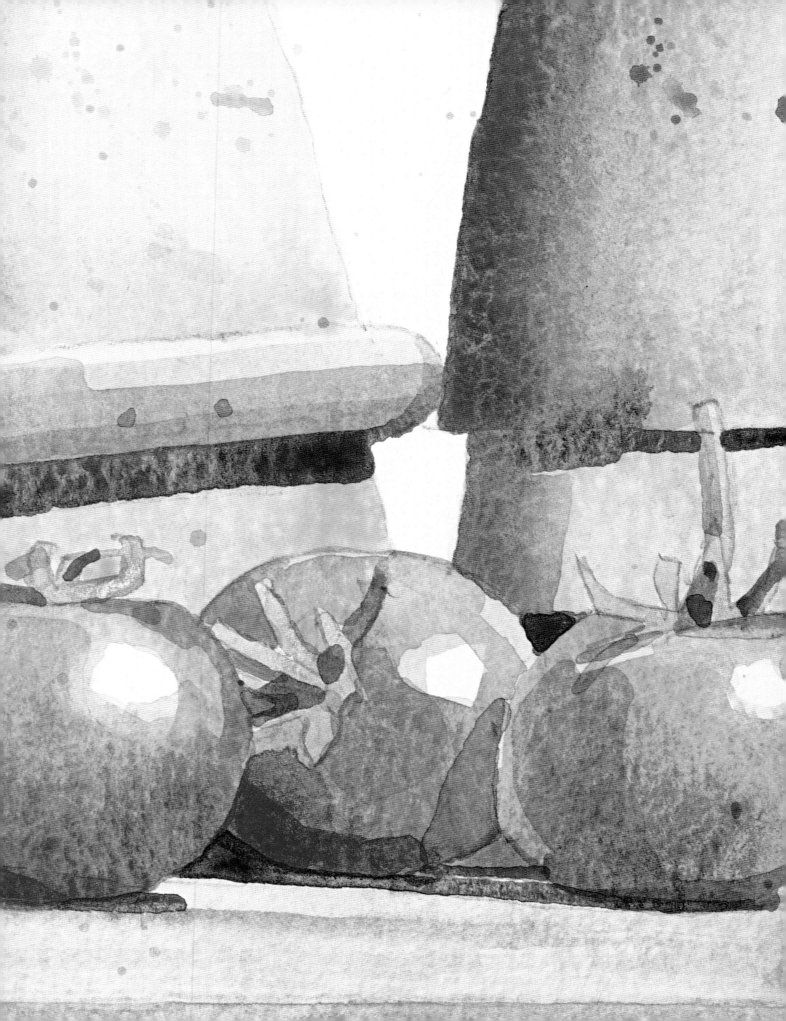

Step 3
watercolour
techniques

focus: flowerpots and tomatoes

Materials

25 x 30 cm (10 x 12 in) sheet of
535 gsm (250 lb) NOT surface
watercolour paper

HB graphite pencil

No. 8 round synthetic-fibre brush

Medium-sized rigger brush

Medium-sized bristle fan blender

Paper towel

Scrap paper

The palette:

- *Cadmium red medium*
- *Cadmium yellow medium*
- *Ultramarine blue*
- *Pthalocyanine green*
- *Burnt umber*
- *Raw umber*
- *Yellow ochre*
- *Mars black*

By diluting acrylic colours with water alone, it is possible to create transparent washes of colour that resemble watercolour. The main difference is that, while watercolour remains to some extent soluble when dry, acrylic paint is permanent once dry and cannot be removed or modified by re-wetting.

USING ACRYLIC PAINTS AS WATERCOLOURS

In rendering acrylic paints to work as watercolours, it is important to choose colours that are considered translucent or transparent and to add plenty of water to the mixes to keep the paint fluid. Avoiding the addition of any white paint is also key. Furthermore, it is impossible to soften unwanted hard edges once the paint is dry, so you need to do any blending while your work is still wet. Using a retarding medium helps here, as does the addition of a flow medium (see Painting mediums and additives, page 13), although you must be careful when using either, as they can rapidly give your work the look of painting on blotting paper!

Thin washes of paint are generally applied using synthetic-fibre brushes, but you can produce a whole range of interesting effects and marks by utilizing bristle brushes, painting knives, paint shapers and sponges, not to mention implements like cocktail sticks, cotton wool buds, hair combs and toothbrushes. In addition to the watercolour techniques that follow, a number of paint techniques are discussed later (see Step 8, pages 80–89), which could equally apply here (masking, scumbling, spattering and sgraffito).

Wet into wet

Applying a wash onto an already wet surface is described as 'wet into wet'. The surface may be wet from a previously applied wash of colour or from a wash of clean water. Depending on how wet or damp the surface is, the colours run and bleed into one another and slowly diffuse over the surface. The effect is soft and amorphous, creating forms and shapes that are undefined and lacking focus. Wet-into-wet techniques are only partially controllable and are usually used together with wet-on-dry techniques.

Wet into wet

Wet on dry

Back-runs

Blending

Dry brush

Highlights

Wet on dry

With 'wet-on-dry' techniques you apply a wash to a dry surface. The paint does not bleed but stays where it is put. This produces areas of colour with hard edges that are sharp in focus and clearly defined. You can use this technique to build up colour and tone, as each transparent wash qualifies and alters the (still visible) layer beneath.

Back-runs

Characteristic of wet-into-wet techniques, these watermark effects happen when you apply a fresh wash over a previously applied wash that is not completely dry. You can manipulate back-runs to a certain extent, perhaps using them to suggest pictorial elements in landscape work, for example.

Blending

Acrylic paint cannot be made resoluble once dry, so you have to carry out any blending or softening of edges while the paint is still wet. When an edge needs to be softened, one solution is to apply clean water along the extent of that edge and bring a coloured wash up to it. The colour then bleeds into the water becoming slightly lighter. This technique requires practice.

Dry brush

Dry-brush techniques are used for breaking up flat areas of colour and creating a range of textural effects. This is achieved by removing most of the wet paint from the fibres of the brush, before applying the minimum amount of paint to the paint surface. This results in a 'dry' mark, and is a useful technique for painting fabric, grass or the fur and feathers of animals and birds.

Highlights

The best way to create highlights is by preserving light colours or the white of the paint surface, which you do either by working around the desired area or by using a form of masking.

PAINTING THE FLOWERPOTS AND TOMATOES

The following exercise allows you to practise mixing thin, transparent washes of varying colour and tone without using white paint. You will also learn about wet-on-wet and wet-on-dry techniques, how to build up and modify colour using layers, and how to use a few different brush techniques to achieve different effects.

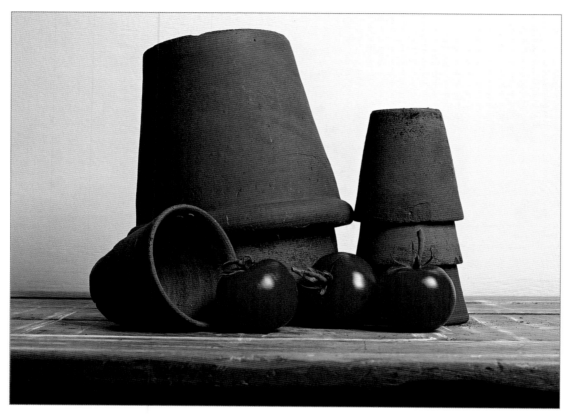

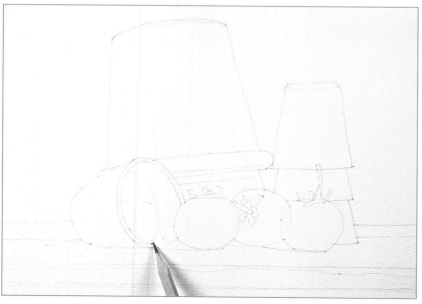

1 Use a heavyweight watercolour paper of 535 gsm (250 lb) so you will not have to stretch it first. Use the pencil to make a light drawing to act as a guide. Do not make your lines too dark or they will show through the thin washes of colour that follow.

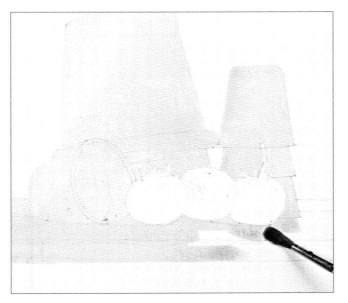

2 The first wash consists of a light terracotta colour, which you make by mixing burnt umber, cadmium red and a little yellow ochre. Lighten the colour by adding water. If you wish, you can test the transparency and depth of colour of your mixes on a sheet of scrap paper before applying them to your painting. Using the no. 8 synthetic-fibre brush, wash this colour over the flowerpots. Use water with all of your mixes for this project, but do not add acrylic painting medium or any white paint. Add a little yellow ochre and raw umber to the previous mix and use this to apply a wash over the tabletop. Do not be concerned if this colour runs into and mixes with the colour used to paint the pots.

3 Add a little pthalocyanine green to yellow ochre to create a light green, and use the rigger brush to apply this to the stalks of each tomato. Allow the green to dry before applying a light orange-red mix to each tomato. Make this by mixing together a little cadmium red and yellow ochre and apply, still using the rigger brush, leaving small areas of the white paper unpainted to represent the highlights.

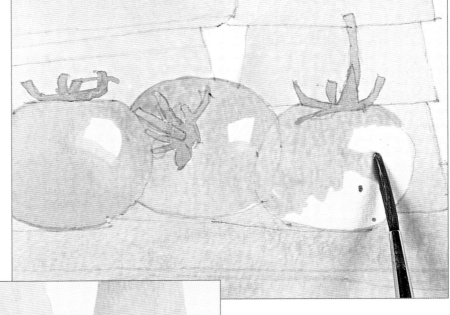

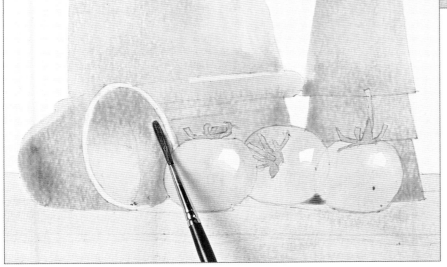

4 Allow the tomatoes to dry while you mix a deeper terracotta colour using burnt umber, a little cadmium red and a little yellow ochre together with plenty of water. Use this colour to repaint the mid tones on the flowerpots. In those areas where the colour is more intense, allow the paint to puddle a little and leave to dry naturally without disturbing it.

5 Meanwhile, mix a dark brown using burnt umber and mars black. Wash this over the area beneath the tabletop using the no. 8 brush. Now mix a deep red using cadmium red and cadmium yellow and repaint the tomatoes using the rigger brush. At the point where the tone changes, apply clean water and brush the paint up to it: the colour will bleed into the area covered in water, gradually becoming lighter.

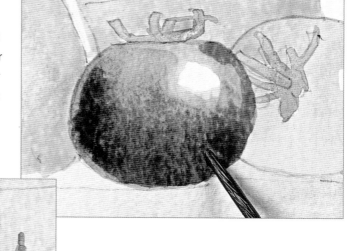

6 Once you have finished the tomatoes, repaint the stalks using a dark green mixed from a little pthalocyanine green and yellow ochre, subdued by adding a little cadmium red. Allow the tomatoes to dry completely before continuing.

7 Mix a deep terracotta colour using burnt umber, a little cadmium red and ultramarine blue. Brush clean water onto the side of each pot that is to remain light and apply the darker colour so that it touches the wet area: it will bleed into the water creating a graduated tone. Where the colour is very dark, allow the paint to puddle and leave to dry undisturbed.

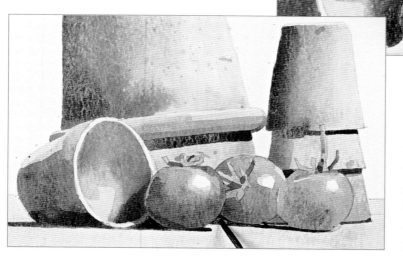

8 Once completely dry, use the same colour to add a few spatter marks to the pots, rendering the flaws in their surfaces. Blot off any unwanted spatters from the background using paper towel. Mix a deep brown using burnt umber and ultramarine blue, and use this for the shadows beneath the upturned pots and the tomatoes.

9 Lighten what remains of the dark-shadow mix by adding a little water and use to create the wood grain on the tabletop, applying a dry-brush technique: dip the fan blender into the paint and wipe the brush on paper towel so that most of the paint is removed before making any marks. Practise the technique on a separate sheet of paper before committing yourself.

10 Return to the rigger brush and complete the work by painting the edge of the tabletop with a mix made from yellow ochre and burnt umber. Add cadmium red to this mix to strengthen the shadows on the tomatoes.

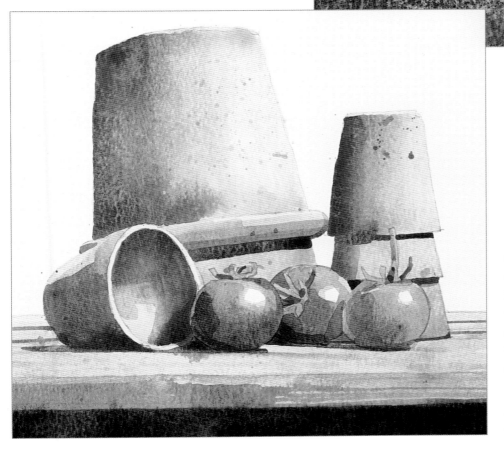

11 The completed painting demonstrates how much actual colour is needed to create a suitable transparent wash, how much water is needed in the mix, and how the wash is distributed onto the support. You will also have learnt how to build up tone and colour using layers, and how to integrate a number of watercolour techniques into the same image.

Step 4
glazing
techniques

focus: garden tools

Materials

25 x 30 cm (10 x 12 in) MDF board
 prepared with gesso

2B graphite pencil

Gloss acrylic painting medium

6 mm (¼ in) flat synthetic-fibre brush

Medium-sized rigger brush

The palette:

- *Titanium white*
- *Cadmium red medium*
- *Cadmium yellow medium*
- *Ultramarine blue*
- *Dioxazine purple*
- *Raw umber*
- *Yellow ochre*
- *Mars black*

Glazing is a traditional oil-painting technique, similar in principle to watercolour. In each case, you apply transparent layers of paint in order to qualify and modify the layer beneath. Acrylic paint is perfect for using with glazing techniques because the paint dries very quickly, allowing you to build the layers with relative speed. You can complete a work using this technique alone, or with various other techniques, including impasto (see Step 5, pages 54–61).

Most painting techniques involve mixing the paint physically on the palette before applying it to the paint surface. The paint has body and is invariably relatively opaque. The same is true when using glazing techniques, although the colours tend to be simpler and more pure. The difference here is that painting medium is added to the paint at the mixing stage to make it very thin and transparent – rather like a watercolour wash.

TONAL UNDERPAINTING

An intrinsic and important part of the traditional glazing technique is the tonal underpainting, or 'grisaille'. This is usually carried out using tones of grey. It resembles a black-and-white photograph and should be made

Glazing: You can alter the appearance of one paint layer simply by applying a second, transparent, layer of paint over the top.

Adding glazing medium: Acrylic paint manufacturers produce a glazing medium specifically for glazing techniques, although gloss painting medium can also be used.

so that the tones are slightly lighter than in reality and any deep black tones are dark grey. Any colour can be used for a tonal underpainting, as long as the result is monochromatic – that is, completed in tones of a single colour. Bear in mind, however, that any colour used for the underpainting will have a profound effect on the appearance of the colours that are applied as glazes over the top.

Working with a tonal underpainting in this way means that you make the most of the tonal considerations at an early stage and the subsequent colour mixes are relatively simple because the value of the tones reading through the thin glaze of paint do most of the work. The technique is therefore ideal for those who experience difficulty mixing the correct value colour as it divides the decision-making into two distinct parts: tone then colour.

USING COLOURED GLAZES

You can use a glaze to modify colours at any time during the execution of a painting, whatever the technique being used. For example, you could apply an all-over glaze of a suitable colour to finish off a painting. This is a relatively popular device that has

the effect of unifying and harmonizing all of the colours used to create an image. You can also apply a glaze to calm down and subdue an image in which the colours are considered to be too bright or strident.

The important thing to remember when using a glaze, is that it brings a completely different quality to a painting than is seen in works where the colours have been physically mixed together: glazed images seem brighter and more jewel-like. They seem possessed of an inner light with a greater depth of rich colour, which can be difficult to achieve using paint that has distinct volume or body.

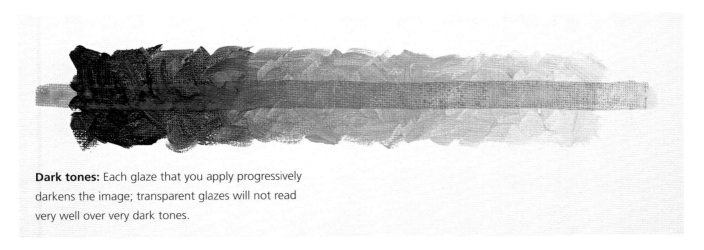

Dark tones: Each glaze that you apply progressively darkens the image; transparent glazes will not read very well over very dark tones.

PAINTING THE GARDEN UTENSILS

This project demonstrates how to use glazing techniques to modify both the tone and the colour of an image – a valuable exercise that can be used with other painting techniques. With this arrangement of garden utensils, you need to think about colour and tone separately and so are forced to look hard and analyze what you see in depth.

1 On the hard, white surface prepared using gesso, make a light pencil drawing using the 2B graphite pencil. Keep the drawing relatively light, as a dark graphite line might 'read' through the thin, transparent glazes of paint.

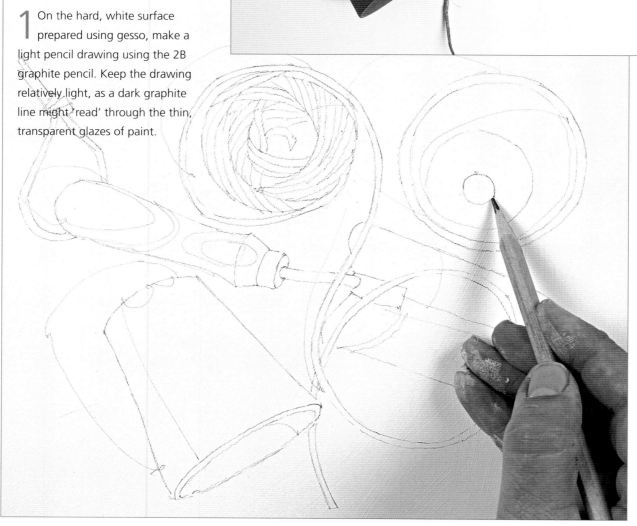

2 Create the grisaille, or tonal underpainting, using shades of grey made from mars black and titanium white. You can make opaque mixes for the underpainting, but here they are mixed together with plenty of water and gloss painting medium to keep the colours relatively transparent. Begin by establishing the lightest tones using the 6 mm (¼ in) synthetic-fibre brush.

3 Once the lightest tones are dry rework the image, painting in the range of slightly darker, medium tones. As before, keep the paint mixes reasonably transparent by adding gloss painting medium along with water.

4 Once the paint is dry, darken the grey mix further. Now seek out, and establish, the darker mid tones. Establish the darkest tones last of all. Remember not to make these too dark or the glazed colour will not read and may possibly look too dark.

5 Apply the first glaze to the terracotta flowerpots. Mix the colour using cadmium red, cadmium yellow and yellow ochre, adding plenty of gloss painting medium and water to keep the glaze transparent. Apply the paint smoothly, still using the 6 mm (¼ in) brush. Notice how the tonal underpainting immediately reads through the coloured glaze to create the form of the object.

6 Darken the flowerpot mixture a little by adding more cadmium red and yellow ochre. Once the previous glaze is dry, repaint the flowerpots concentrating on those areas of mid and dark tone.

7 Mix a dull brown using raw umber and yellow ochre and apply a light glaze to the ball of string, the blade of the trowel and the handle of the trowel.

8 Now mix a blue-grey using a little mars black with ultramarine blue added to it. Use this colour to paint the dark, reflected colour seen on the blade of the trowel. Work carefully around the string that curls over the trowel blade and those areas on the blade that are light in tone or highlighted.

9 Add a little dioxazine purple to raw umber and use this to add colour to the shadows cast by the pots and the trowel, and to add a little definition to the trowel handle. You can also use this colour to paint in the darker tones seen on the ball of string. Add a little mars black to paint the dark hole at the centre of the string. Mix a little raw umber with titanium white and, using the rigger brush, begin to give definition to the separate coils that make up the ball of string. Notice that this colour is more opaque than previous mixes, owing to the addition of white.

10 Finally, using a mix of just titanium white, water and painting medium, repaint the background, redefining the edges of each object as you work. Use a little of this mix to add a slightly lighter tone to the blade of the trowel.

11 In completing the painting, you will have discovered how to assess tone and colour separately, how to mix your colours so they are relatively transparent and how to build up the density of colours by working in layers.

Step 5
impasto
techniques

focus: a bunch of radishes

Materials

25 x 30 cm (10 x 12 in) prepared
 canvas board

Hard charcoal pencil

Fixative

Matte acrylic painting medium

Heavy gel painting medium

6 mm (¼ in) flat bristle brush

12 mm (½ in) flat bristle brush

Small trowel-shaped painting knife

The palette:

- *Titanium white*
- *Quinacridone red*
- *Cadmium red medium*
- *Lemon yellow*
- *Ultramarine blue*
- *Pthalocyanine green*
- *Raw umber*
- *Yellow ochre*
- *Mars black*

'Impasto' painting techniques are quite the opposite to glazing techniques (see Step 4, pages 46–53) and involve applying the paint thickly – sometimes very thickly indeed – so that the marks of the brush, or other means of application, are left visible. Again, this is a traditional oil-painting technique that can be accomplished in far less time, owing to the quick-drying nature of acrylic paint.

The word *impasto* is Italian and means 'dough'. It describes the character or consistency of the paint, although in reality the paint should be more the consistency of soft butter. Impasto paintings have an almost tactile quality to them and the paint takes on a physical appearance: in really thick impasto work, the paint appears almost modelled into a third dimension. The surface of impasto work has a certain liveliness – the paint changing depending on the way light falls upon it – while the textural quality of impasto work makes it very expressive.

Mixing the paint: Use a palette or mixing knife to mix your paint. It is easier to clean than a brush and not so easily ruined.

Making mistakes: Correct any mistakes as you make them. This is simply done by scraping off the offending area using a palette or painting knife. You can then repaint the area in question, often reusing the paint you have just removed.

USING A PAINTING MEDIUM

Impasto work uses a large quantity of paint and, while the consistency of paint straight from the tube is ideal, it will not be long before you are on a trip to the art store to buy more. Mixing your paint with a heavy gel medium is more economical and the gel is exactly the right consistency for the technique. As with acrylic mediums of an ordinary consistency, heavy gel mediums are available that dry to leave a matte or a gloss finish. When using heavy gel mediums you will find it easier to mix the desired colour first, then add the required amount of medium: the paint colour should only alter slightly. A mix of thick paint and heavy gel medium will take longer to dry than normal. If you wish, you can extend the drying period further by adding a little retarding medium.

Exploiting the technique: Although brushes and painting knives are popular tools for impasto work, do not overlook the possibilities presented by combs, pieces of cutlery and bits of wood among others.

WORKING THE IMPASTO

It is easy to run into difficulties if you use very thick paint from the outset; it is far more practical to make an underpainting first using a thinner application of paint. Establishing the composition in this way serves as a guide for the thicker applications of paint to come, and helps mitigate any mistakes and wasted paint.

Use harder fibre brushes to apply the paint and keep your brushwork multi-directional. It is easy to build up an image in which all of the brushmarks run in the same direction, but this tends to limit the effect of impasto work, pulling the eye in the general direction of the massed brushmarks, rather than allowing the eye to wander around the composition in a more general way.

It is not always necessary to complete an entire painting using impasto techniques. Many artists use thinner paint techniques, resorting to applications of impasto for emphasis or to suggest physically, or represent, a texture. You can use many different tools to apply and manipulate the paint, including painting knives (see Step 6, pages 62–71).

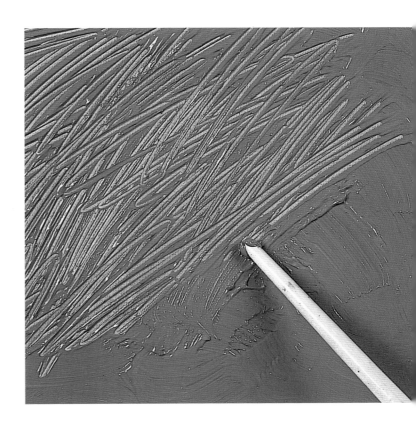

PAINTING THE BUNCH OF RADISHES

Using thick applications of paint requires you to work precisely and with a certain surety – play with the paint surface too much and it becomes a mess. This project demonstrates how to mix the paint to the required consistency and to apply it using precise, directional brushstrokes or marks that have a certain economy.

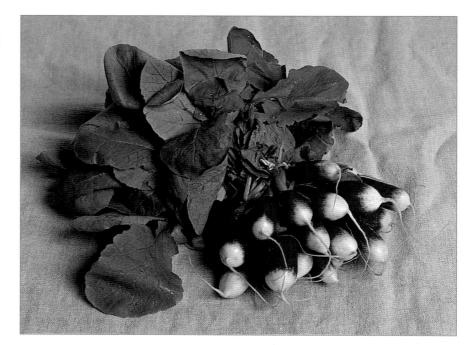

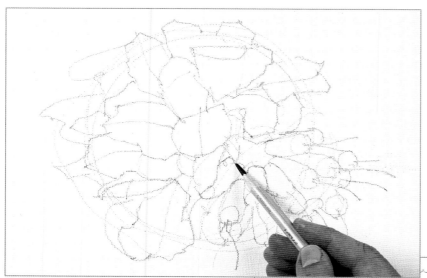

1 Start by making a simple charcoal line drawing to help keep the painting on track. Once happy with your composition, give the drawing a coat of fixative in order to prevent the black charcoal dust mixing with the colours in the subsequent underpainting.

2 Establish the underpainting, using the 6 mm (¼ in) bristle brush and a mixture of mars black diluted with water and a little matte painting medium. Block in the darkest shadow areas. Still working on the underpainting, mix a red for the radishes using quinacridone red and cadmium red, and block them in. Avoid a build-up of paint at this stage by keeping the consistency of your paint thin.

3 Now mix a bright green using pthalocyanine green and lemon yellow with a little added yellow ochre to subdue the colour. Use this mixture to block in the radish leaves. Allow the paint to dry completely before continuing.

4 You can now start the impasto work: all of your mixes from this point on will have heavy gel medium added to them in order to add body. Paint the radishes first, using the 6 mm (¼ in) flat bristle brush and directional brushstrokes that hint at the form of your subject. Mix several variations of red for this from quinacridone red, cadmium red, lemon yellow and titanium white.

5 Apply a dab of pure titanium white to the end of each radish.

6 Mix various bright greens for the radish leaves using pthalocyanine green, lemon yellow, ultramarine blue and titanium white. Keep the paint thick and juicy and use directional strokes to help suggest the angle and fall of each separate leaf.

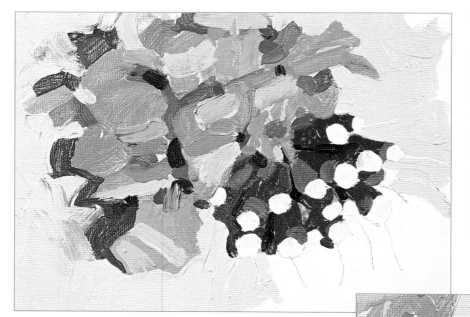

7 Mix a dark, neutral colour from raw umber and ultramarine blue into which you add titanium white and use this to paint the dark shadows around the radishes and the leaves. Use a light-ochre mix made from yellow ochre, raw umber and titanium white for the background. Apply this last colour using the 12 mm (½ in) bristle brush, changing to the 6 mm (¼ in) brush to work closely cutting in around the roots of the radishes.

8 Before the background colour dries, use the trowel-shaped painting knife to scrape away some of the paint around the ends of the radishes to reveal the white of the support and, in doing so, to suggest more roots.

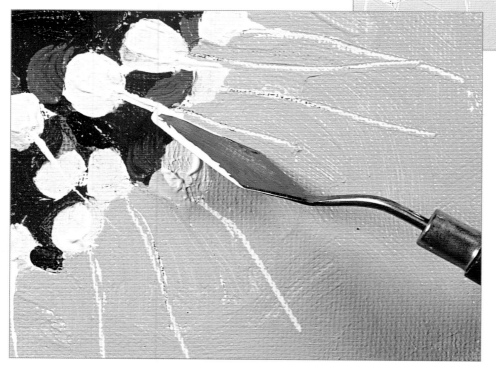

9 Use the side of the same painting knife to apply thin lines of titanium white paint to add to the suggestion of more roots. As the paint is pulled from the knife, the mark should become thinner, just as the root does in reality.

10 Complete the image by repainting the background using a light-beige mix made from raw umber, yellow ochre, mars black and titanium white. Apply the creamy paint using the 12 mm (½ in) bristle brush, changing to the 6 mm (¼ in) brush in the tight spaces between the roots.

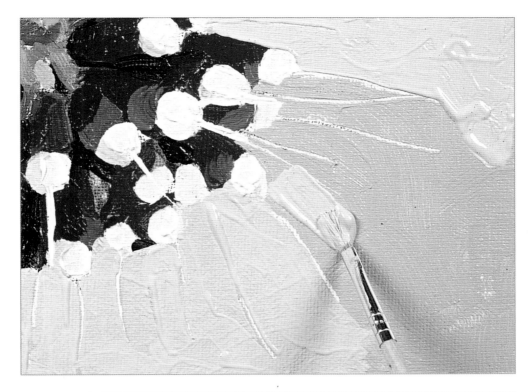

11 You can see from the finished painting, how the application of a thin underpainting avoids the need for too much detail in the subsequent layers of paint. By using simple marks and textures that often hint at more than they actually show, you keep the impasto work lively and interesting.

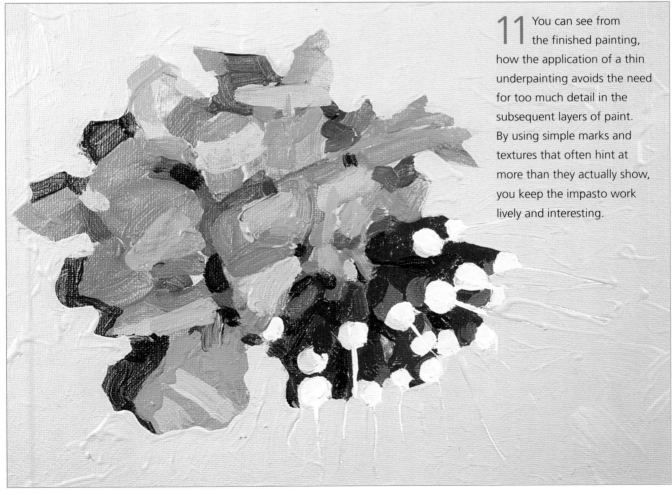

Step 6
painting-knife
techniques

focus: onions and garlic

Materials

25 x 30 cm (10 x 12 in) prepared
 canvas board

Hard charcoal pencil

Fixative

Heavy gel medium

6 mm (¼ in) flat bristle brush

Small trowel-shaped painting knife

Spatula-shaped painting knife with
 angled end

The palette:

- *Titanium white*
- *Quinacridone red*
- *Cadmium red medium*
- *Ultramarine blue*
- *Dioxazine purple*
- *Raw umber*
- *Burnt umber*
- *Yellow ochre*

Although brushes are seen as the most common – and certainly most controllable – way of applying paint to a surface, they are not the only option available. In previous sections you are encouraged to experiment with various 'found' tools in order to bring different qualities to the marks that you make (see Steps 3 and 5). The painting knife was invented for exactly this purpose and, although originally restricted to use with thick impasto paint, it is a missed opportunity not to exploit it further.

USING PAINTING KNIVES

Painting knives come in many different shapes and sizes and, in order to maximize their potential, you would do well to buy several. The tempered steel blade flexes under pressure and, in experienced hands, can be as sensitive and delicate to work with as a brush. Each differently shaped painting knife will deliver a surprising range of marks both in applying the paint and removing it.

The removal of paint, and the effects of sgraffito (see Step 8, page 83), are often overlooked yet they are just as important as the application of paint. Textures, patterns and linear effects

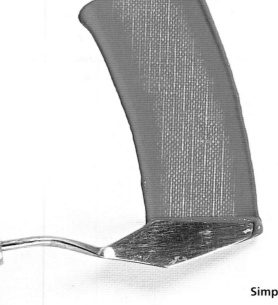

Simple marks: The flat blade delivers a paint mark that is the same length as the blade itself.

are often more easily achieved by working back into wet areas of paint than by trying to create the same effect with more paint. If you do choose to work in this way, the paint will need to be workable, so use a retarding medium (see Painting mediums and additives, page 13) to keep the paint 'open', giving you more time to work. Conversely, the fast drying time of acrylic paint can work to your advantage, making it possible to build up complex layers of paint that have been worked into with the knife, thereby revealing elements of the surface below.

ESTABLISHING AN UNDERPAINTING

As with impasto work, it can be a mistake to allow too heavy a build-up of paint too early on and, once dry, you will not be able to remove the paint. The answer is to work over a thin underpainting. You can make this using a brush or, if you prefer, the painting knife. In the case of the latter, you apply the paint to the surface in the desired areas, but scrape it off again before it dries. This leaves you with a pale ghost of the image. Once dry, you can continue to work on the underpainting using thicker paint.

USING PALETTE KNIVES AND PAINT SHAPERS

When using a palette knife with thin, fluid paint, the application technique is slightly different, because it is almost impossible to pick up large quantities of paint on the blade. A certain amount of paint will cling to the blade, but not enough to cover a large area. One solution is to apply the paint initially with a brush, then use the knife to manipulate and move it around the paint surface.

Silicone-rubber paint shapers come in various shapes and are a useful addition to your arsenal of mark-making tools, complementing the painting knife perfectly. Each handles more like a conventional brush and makes a range of marks that you will find very useful and slightly different in quality to those made using the knife.

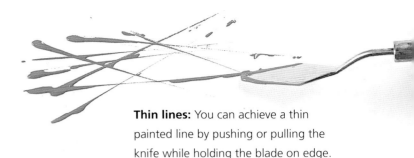

Thin lines: You can achieve a thin painted line by pushing or pulling the knife while holding the blade on edge.

Painting dots: Use the very tip of the blade to make a series of dots.

Creating textures: By using the flat of the blade to stipple the paint, you can create a wide range of textures.

Thick lines: By turning the knife in your hand while making a mark, you can produce a stroke of varying thickness.

PAINTING THE ONIONS AND GARLIC

The rough, papery textures of the onions and garlic are ideal for experimenting with painting and palette knives. The marks possible when using a painting knife are completely different to those made when using a brush and can bring qualities to an image that are both rich and exciting.

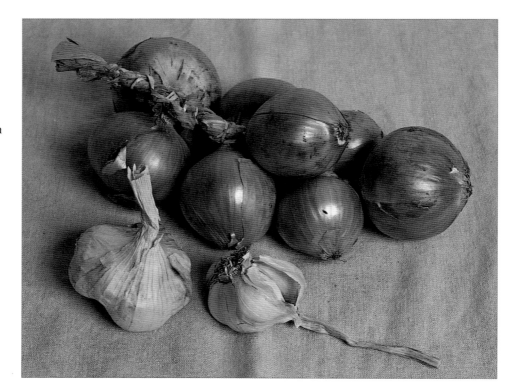

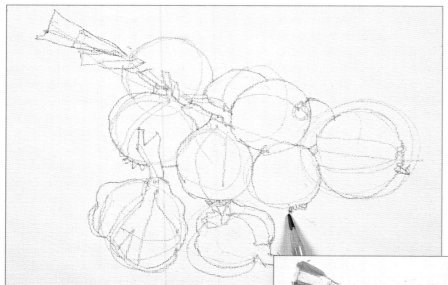

1 Begin by using the charcoal pencil to sketch in the composition. Once finished, give the drawing a coat of fixative if you wish, in order to prevent the charcoal dust mixing with subsequent applications of paint.

2 Make a thin underpainting to establish the colours and shapes of the main elements, providing a good base on which to build the knife work. Using the 6 mm (¼ in) bristle brush, mix a dull pink from yellow ochre, quinacridone red and titanium white. Use shades of this to block in the overall colour of the onions. There is no need to add any medium to any of these mixes, just use water.

3 Block in the colour of the garlic bulbs in the same way, using mid-tone mixes of titanium white and raw umber.

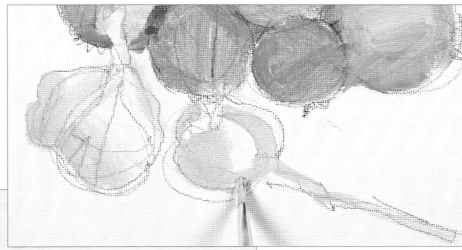

4 Now establish the background colour. Mix the colour for the shadows cast by the onions and garlic by using raw umber with ultramarine blue and titanium white. Make the main background colour by mixing together titanium white, raw umber and a little yellow ochre.

5 With the underpainting complete, and dry, you can continue the work using painting knives. In order to give the paint the necessary body add heavy gel medium to your mixes from now on. Begin by mixing a dull pink, similar to the colour of a sticking plaster, made from burnt umber and yellow ochre. Lighten this considerably by adding titanium white and give it a pink tinge by adding a small amount of quinacridone red. Use the small trowel-shaped painting knife to apply this to the onions. Use the blade of the knife to follow the shape of the onions, manipulating the end and side of the blade to apply the paint to the twisted stems.

6 Darken the onion mix using raw umber and a little cadmium red and paint the darker, mid-tone areas in the same way. Now mix a light ivory colour using titanium white, a little raw umber and a very small amount of ultramarine blue. Use this to establish the mid-tone areas of delicate colour on the bulbs of garlic.

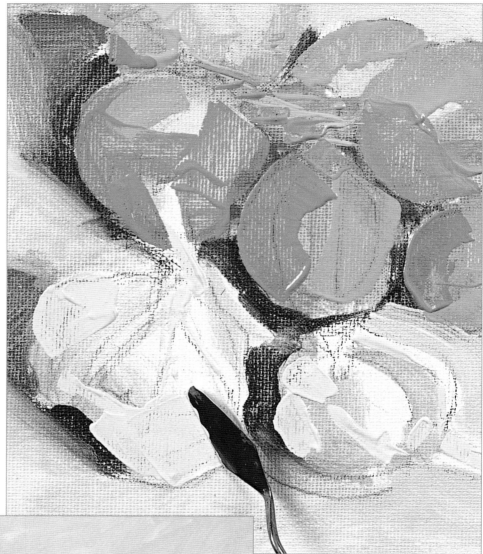

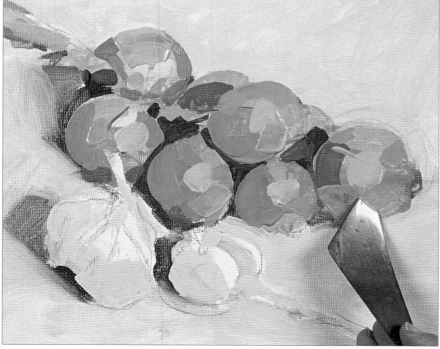

7 Wait for the paint on the onions to dry before applying further layers. Mix a rich, light brown using burnt umber, yellow ochre and titanium white with just a touch of quinacridone red. Darken this colour by adding more burnt umber and dioxazine purple, or lighten it by adding more titanium white. Apply the paint with the spatula-shaped knife, using the small-width blade to make short directional paint marks to develop and consolidate the spherical shape of each onion in turn.

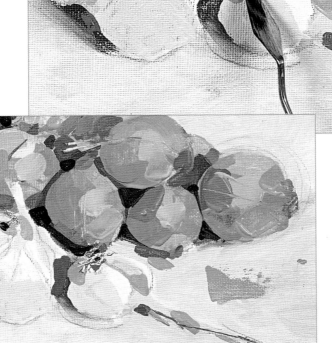

8 Make a darker mix for the garlic using raw umber with a little ultramarine blue and titanium white. Return to the trowel-shaped knife and use this mix to establish the small patches of darker colour seen on each bulb. Darken the mix further by adding more raw umber and ultramarine blue and apply this colour to the base of the garlic to represent the cluster of dry roots. Using the edge of the knife, pull a dark line of colour out from the bulb along the length of its brittle stem.

9 While the paint is still wet on both the onions and garlic, scratch into the paint to reveal the layer beneath. Use this technique to suggest both the linear marks on the skin of the onions and the light roots on the garlic.

10 Stay with the trowel-shaped knife to apply the shadows beneath the onions and garlic, using mixes similar to those used for the garlic in step 8.

11 Repaint the background using a light colour made by mixing together titanium white, raw umber, a little yellow ochre and a touch of ultramarine blue. Cut in carefully over and around the shadows, amending and redrawing the shapes of the vegetables as you apply the paint. Be liberal with the paint and use relatively short strokes.

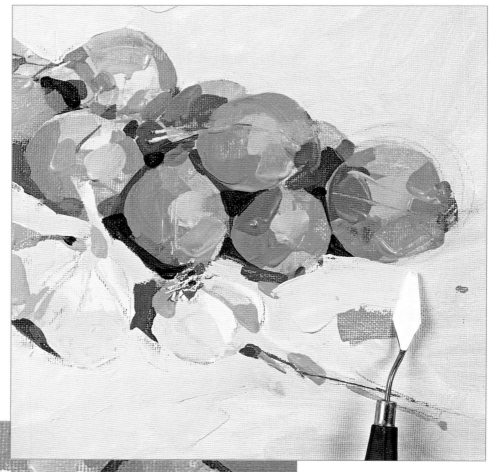

12 Apply pure titanium white to the lightest part of each garlic bulb using the small-width blade on the spatula-shaped knife.

Black lava: flecks of black lava can either be allowed to show or be fully incorporated into the paint mix.

Resin sand: gives a subtle granular effect.

Glass beads: a slightly larger aggregate gives a more pronounced texture.

Blended fibre: this creates a softer, fluffier effect.

simply by adding suitable aggregates to your paint, together with a gel medium. Clean children's play sand, plaster, sawdust and even gravel or dried vegetation and leaves, can be added in this way.

PAINT SURFACES AND BRUSHES

Texture and modelling pastes tend to be quite heavy and, used in any quantity, can 'pull' at a canvas surface, causing it to sag, so it may make sense to opt for more rigid surfaces like canvas board for these techniques (see Paint surfaces, pages 18–19). Texture paste can also be very harsh on your brushes: it tends to work its way deep into the fibres of the brush you are using and, if not removed, will set hard, causing the fibres to splay. The answer is to clean your brushes scrupulously and use a brush to apply the paste while using a mixing or palette knife to mix the paint on the palette.

PAINTING THE LEEKS AND BROCCOLI

The very nature of acrylic paint means that its handling and consistency can be altered to suit a wide range of picture-making situations. Texture pastes, which alter the actual physical texture of the paint, are an extreme example of this. Learning how to utilize texture pastes can broaden your mark-making and the effects possible. The pastes can also help you solve certain representational problems, as demonstrated here with the head of broccoli.

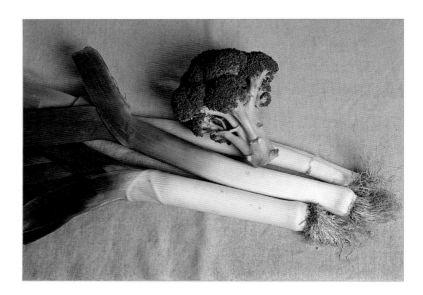

1 Loosely sketch out the composition using the charcoal pencil and give the finished drawing a coat of fixative if you wish. This will prevent the charcoal dust mixing with subsequent layers of paint.

2 Water and matte painting medium are used in the colour mixes throughout this project. Use the 6 mm (¼ in) bristle brush to mix a bright green from pthalocyanine green and cadmium yellow. This will be very bright and can be subdued by adding a little yellow ochre. Vary the concentrations of each colour and use the resulting range of bright greens to block in the leaves of the three leeks. Use your brushmarks to render the linear pattern on each leek. Take a little of the bright green and add titanium white to lighten it and a little ultramarine blue to transform it into a cool blue-green. Use this to establish the basic colour of the broccoli head. Add more titanium white to mix the colour for the paler stalk.

3 Create the background colour by mixing titanium white with a little raw umber and a little yellow ochre. Apply this to the area of the leek roots and, using the trowel-shaped painting knife (or the pointed wooden end of the paintbrush), mark the tangle of roots into the wet paint.

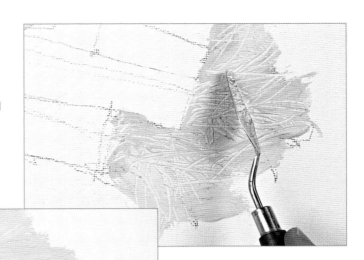

4 Return to the 6 mm (¼ in) bristle brush and loosely work the same mixture over the entire background.

5 Make a dark green with the same brush, using pthalocyanine green, raw umber and yellow ochre, and paint in the dark tone of green that runs around the top of the broccoli florets. Lighten the mix by adding titanium white and a little ultramarine blue. Now add black lava texture paste and use the mix to paint the rest of the broccoli head.

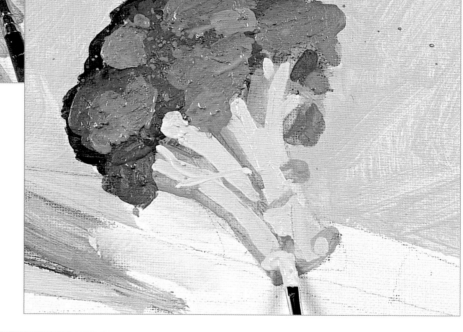

6 Allow this paint to dry before applying another layer in a slightly different shade of green, using the 6 mm (¼ in) bristle brush. Repeat the process, gradually building up the texture until the desired effect is achieved.

7 Mix a light green from pthalocyanine green, cadmium yellow, a little yellow ochre and ultramarine blue. Lighten the mix with white and use this to paint the stalk with the 6 mm (¼ in) synthetic-fibre brush, applying the paint relatively thickly so that it has a degree of physicality about it and the brushmarks are apparent.

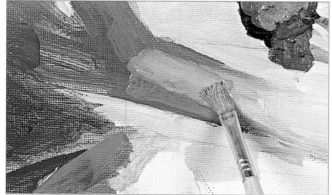

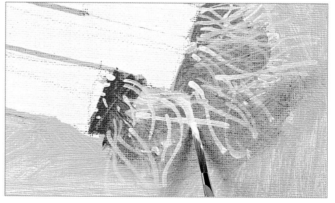

8 Rework the leek leaves with the 6 mm (¼ in) bristle brush using the same light-green mixes made in step 2, with added cadmium red and white. Do not overwork this area, as you may obscure the brushmarks that show the linear patterns.

9 Using the rigger brush, mix yellow ochre with raw umber and apply to the area of fine roots at the base of each leek. Once this is dry, paint the roots, again using the rigger brush and a light mix made from titanium white with a little raw umber and yellow ochre.

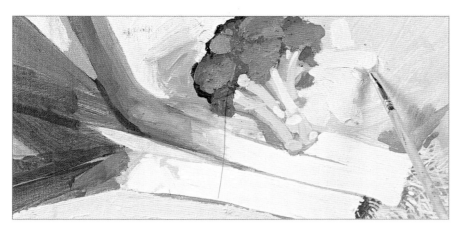

10 Return to the 6 mm (¼ in) bristle brush and repaint the background using a mix made from raw umber, yellow ochre and titanium white, together with the natural sand texture paste. Add more raw umber and a little ultramarine blue into this mix for the shadows. Work the mixture carefully around the head of broccoli.

11 Loosely scribble charcoal over the roots to give them more definition. Mix an off-white using titanium white with a little raw umber and yellow ochre, and repaint the roots using an imprinting technique: tear off a small piece of scrap paper and dip the straight edge into the paint; now bend the paper between your fingers and press the paint-covered edge to the image. This will leave a wavy line that resembles a single root. Repeat the process until you are satisfied with the result.

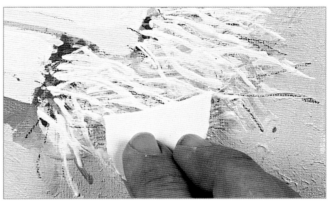

12 In completing this painting, you will have learnt how to mix texture pastes with paint and how to apply them to the support. You will also have learnt that a little goes a long way and how to integrate the pastes into an image using traditional brushwork so that it does not stand out or look out of place.

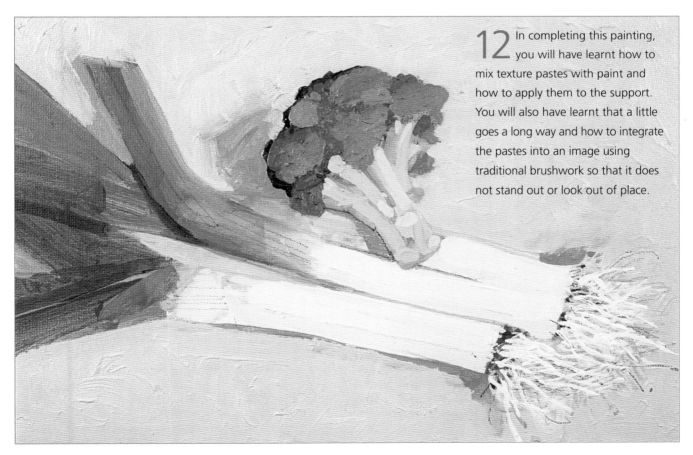

Step 8
paint effects

focus: garden utensils

Materials

40 x 50 cm (16 x 20 in) prepared
 canvas board

Hard charcoal pencil

Fixative

Matte acrylic painting medium

6 mm (¼ in) flat bristle brush

6 mm (¼ in) flat synthetic-fibre brush

Medium-sized rigger brush

Masking tape

The palette:

- *Titanium white*
- *Cadmium red medium*
- *Cadmium yellow medium*
- *Ultramarine blue*
- *Pthalocyanine green*
- *Dioxazine purple*
- *Raw umber*
- *Burnt umber*
- *Yellow ochre*
- *Mars black*

The traditional way of showing surface and texture in a painting is to use clever brushwork in rendering a representation or illusion of the texture in question. This can be done using brushwork alone but there are several other techniques. They either apply or remove the paint in different ways, often using a range of tools that include brushes, knives, sponges or rags – whatever you find that works.

MASKING

Masking techniques are primarily intended to prevent paint getting to areas of the work where it is not wanted. You can also use masking to give a painted area a unique edge quality, especially when using torn paper. When using thick paint make the mask from masking tape, paper or card, cut it to shape and hold it in place while you apply the paint.

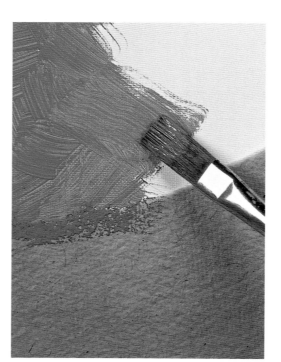

An alternative to using paper or card when using thin paint is to use masking fluid, a rubber solution that you paint onto the support and allow to dry. You can then paint over the area and once this is dry you can remove the masking fluid by gently rubbing it with your fingers.

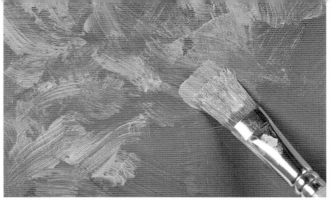

SGRAFFITO

Sgraffito is an Italian word meaning 'to scratch'. For this technique, you scratch or scrape through dry paint using a sharp implement or, for broader areas, sandpaper to reveal the paint surface beneath or, if done carefully, a previously applied wash of colour. You can achieve a softer effect by scraping back into wet paint using the wooden end of a paintbrush.

SCUMBLING

Scumbling refers to the technique of applying an uneven layer of paint over a previously applied layer which has been allowed to dry. You scrub or roll the paint onto the surface using stiff bristle brushes so that the layer beneath shows through. You can use the technique to build up complex areas of colour and texture over several layers. The technique is very successful on textured surfaces, like canvas, but can also be achieved on smooth surfaces.

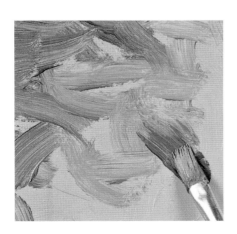

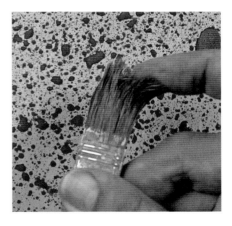

BROKEN COLOUR

This technique usually refers to wet-into-wet applications of paint (see Watercolour techniques, page 40). Here, you apply marks of one colour loosely over another so that, although separate, they tend to blend together slightly to give an area of varied shimmering colour.

SPONGING

Sponges, both man-made and natural, are excellent tools. You can use them to smear paint onto a surface or in a dabbing or stippling action to build up areas of texture. These are good tools to use with scumbling techniques.

SPATTERING

A quick way to add interest and texture to a paint surface is to drop or spatter paint onto it. The technique is usually used with some form of masking. Different brushes and paint consistencies produce different effects as does spattering onto a wet surface rather than a dry one. As with scumbling, you can build up very complex textural effects by working in layers.

PAINTING THE GARDEN UTENSILS

In order to get the most from acrylic paint and to be able to solve representational problems, it is important that you learn as many techniques as possible. There are many different paint effects, each with subtle variations, a number of which are demonstrated and explored in this project. Matte acrylic painting medium should be used to mix the paints thoughout.

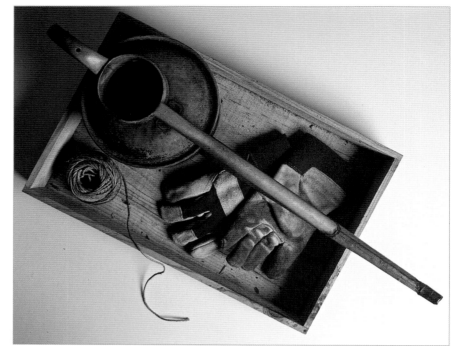

1 Sketch in the composition using the charcoal pencil: it has been arranged to read diagonally across the format, which enables the image to fill the space better. Your drawing can be as elaborate as you wish, but remember that much of it will be lost with the initial applications of paint. Once happy with the sketch, give it a light coat of fixative to prevent charcoal dust mixing with subsequent layers of paint.

2 Establish the watering can first, using a thin mixture made from mars black, raw umber, a little pthalocyanine green and yellow ochre. Modify this dull green-grey mixture with titanium white, and loosely scrub the colour onto the watering can using the 6 mm (¼ in) flat bristle brush.

3 Take a little of the green-grey mix and add a little ultramarine blue and dioxazine purple and plenty of titanium white to produce the light grey for the gloves. For the ball of string, use a mix made from raw umber, yellow ochre and titanium white.

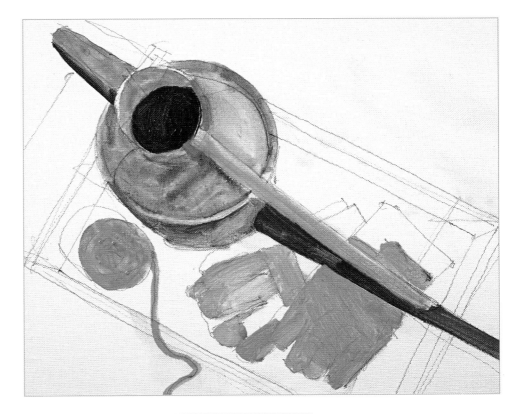

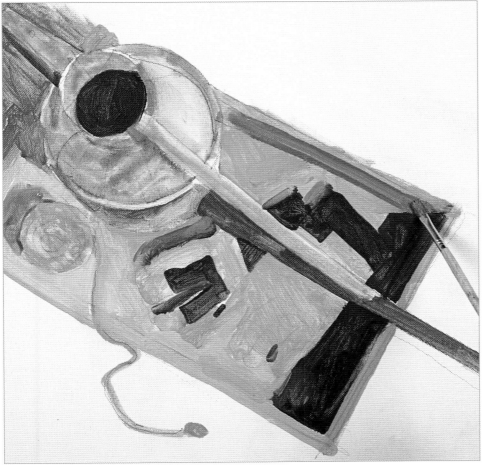

4 Mix together cadmium red and yellow ochre, and subdue the result using a little raw umber. Use this to paint the red of the gardening gloves. Now block in the box using a mix made from raw umber, yellow ochre, a little ultramarine blue and white. By adding a little dioxazine purple to this last mix, you can create the shadow colour at the top left-hand corner of the image. Darken this mix further by adding more raw umber and dioxazine purple and you have the very dark shadow colour that can be seen at the end of the box.

5 Once the paint on the watering can is dry, you can apply a scumbled layer of a dull grey-green made by mixing raw umber with a little pthalocyanine green and yellow ochre. Scrub a little of the same colour onto the gloves. Lighten the mix a little using titanium white and modify with a little mars black to create a range of light greys. Use these to refine the tones on the handle and rim of the can.

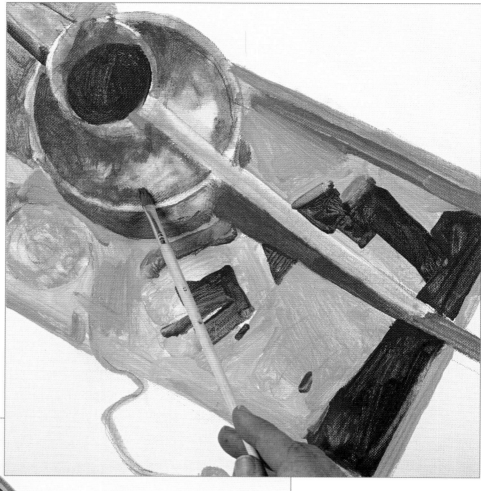

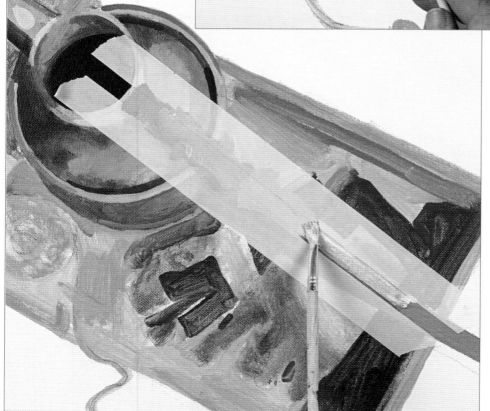

6 In order to get the crisp edge to the spout of the watering can, apply masking tape to the support once the paint is dry. You can then apply the light-grey mix from step 5 and remove the tape.

7 Rework the image, consolidating the colours and tones. Begin the process by repainting the ball of string using the 6 mm (¼ in) synthetic-fibre brush and a raw umber, yellow ochre and titanium white mix. Now move to the gloves, mixing a range of reds based on a cadmium red-yellow ochre mix for the red trim. Use variations of the grey mixed for the watering can to add detail to the fingers of the gloves.

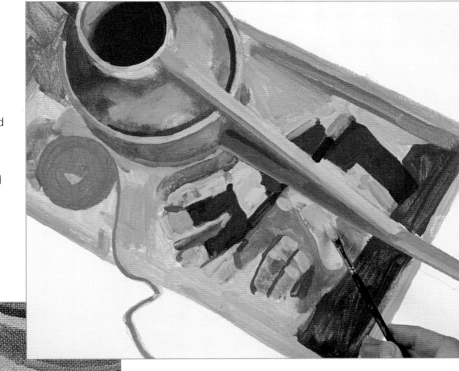

8 Use raw umber and mars black to create a dark colour for the centre of the ball of string. Add a little yellow ochre to this mix and paint in the mid tones. Now lighten the mix considerably by adding titanium white and more yellow ochre, and carefully paint in the string that is catching the light. Use the rigger brush for this, as it will offer more control.

9 For the box, mix yellow ochre and a little cadmium yellow with titanium white. Using the 6 mm (¼ in) bristle brush, paint in the bottom of the box and, while the paint is still wet, inscribe a few lines into the paint using the end of the brush handle, to suggest the grain of the wood.

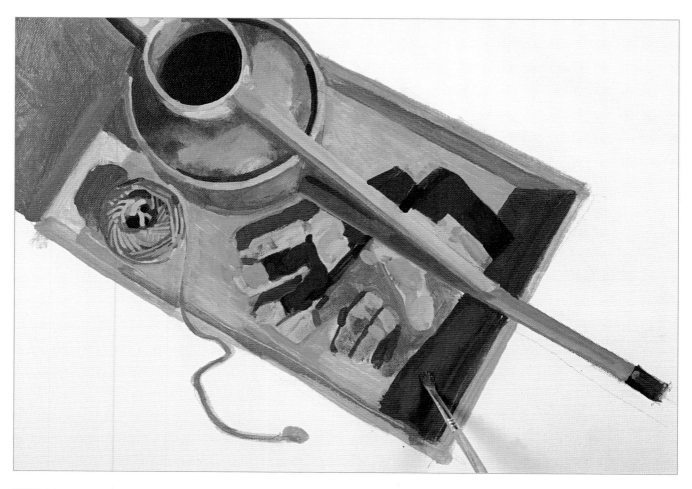

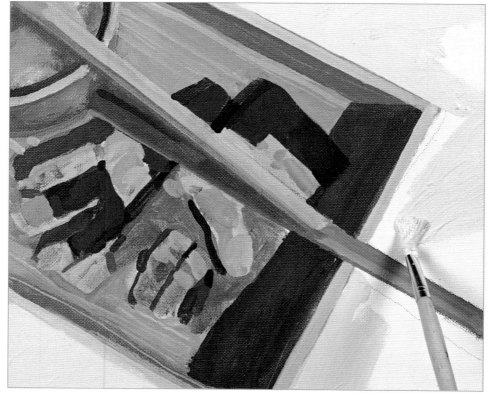

10 Mix a dark, rich brown using burnt umber, a little mars black, a little of the box mix and titanium white. Use this colour to consolidate the shadows cast by the can, the ball of string, the gloves and the end of the box.

11 Mix a light, straw colour from titanium white and yellow ochre. Use this to paint in the edge of the box with the synthetic-fibre brush. Switch to the bristle brush and mix a light cream to establish the background colour, using titanium white and raw umber.

12 Once this is dry, remix the background colour and, using the broken-colour technique, rework the background. Now lighten the colour with white and rework the area, wet into wet, using open, multi-directional brushstrokes.

13 During the course of this project you will have learnt how to use several different techniques in the same image and how to integrate them so that they do not appear obvious or contrived. No single technique dominates over others, but they work together to give a pleasing overall effect.

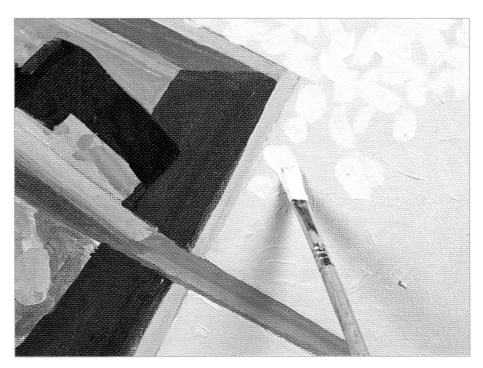

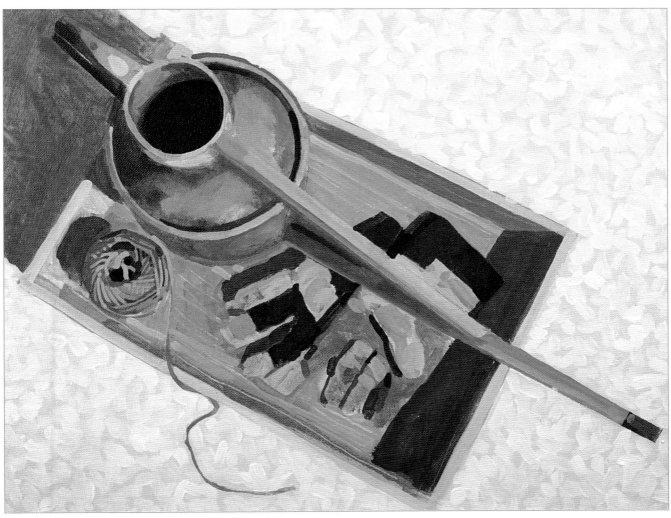

Step 9

composition

focus: arranging the elements

Materials

Cartridge paper

2B pencil

Composition is all about placing or ordering the elements within an image and designing the pictorial space. A good composition seizes the viewer's attention and persuades the eye to follow a predetermined path into and around the work. Bad composition can lessen the impact of a good painting and, while a good composition will not make a bad painting great, it will certainly make it much better. Think of the composition as the foundation, or ground plan, upon which the painting is built.

Make a viewing frame by cutting a rectangular aperture into a piece of card and stretching four rubber bands across so that the aperture is divided equally into thirds horizontally and vertically.

USING A GRID

A design, or composition, can be very simple or very complex. Each of the various artistic disciplines has an effect on the composition – colour, line, tone, scale, texture, light and perspective – and you need to consider each carefully in terms of its impact on the overall design of a piece. Over hundreds of years artists and philosophers have devised various formulae that go some way to help in creating a good composition. Perhaps the best known is the 'golden section'. This is a mathematical formula that divides a line, or an area, in such a way that the size and proportion of the smaller area is to the larger area as the larger area is to the whole. This theory was put to good use in many paintings and was employed by architects when designing buildings, resulting in works of aesthetically pleasing proportions.

A similar device, and one that can provide a basis for the structure of a painting, is the so-called 'rule of thirds'. This simply uses two lines placed across the image horizontally and two placed vertically to divide the area into thirds. Placing important elements on or around the grid lines and the points at which they intersect invariably results in a pleasing composition.

VISUAL BALANCE

One of the most important elements of good composition is achieving what is termed as 'visual balance'. Balance in this instance does not mean

symmetry, but is achieved by relating one element within an image to another. These elements can take quite different forms: for example, you might balance a large object by two small objects; a large area of sombre colour by a small area of intense colour; or a small, highly textured part of the image with a larger, smoother passage. This 'point and counterpoint' is crucial in good composition and sets up something of a rhythm, which the eye is persuaded to follow.

LEADING THE EYE

Persuading the viewer to look at an image and move through or over it in a predetermined way, while holding the attention at specific points, is an important element in any good composition. There can be one focal point or several and you can achieve them in a number of ways, often using colour, or shape, or by introducing a visual pathway. Known as 'lead ins', these pathways might take the form of a path or stream in a landscape, or a swag of material in a still life.

FORMAT

The first consideration when developing a composition is to decide on your format. There are three to choose from – the square, the vertical rectangle and the horizontal rectangle. Each has distinct characteristics to exploit when developing a good composition.

BREAKING THE RULES AND TESTING IDEAS

You can use each of the three formats with great results, and not necessarily conforming to whether they are better suited to landscapes, portraits or still lifes. In fact, artists often create more interesting and arresting images by working against type. Remember that no single compositional device should be used in isolation, but that each has a more or less equal part to play in forming the whole. To this end artists often try out several compositions, either by moving elements within the composition or by changing the position and angle of view.

Square format (top): The square format provides a neutral area, which pulls the gaze equally around its perimeter, causing the attention to spiral ultimately to its centre. This can be a very good format for still lifes.

Portrait format (centre): With the vertical rectangle, the eyes tend to travel up and down the area, making it a favourite format with portrait painters.

Landscape format (bottom): The horizontal rectangle persuades the onlooker's gaze to move from side to side across the area, making it an ideal format for landscapes.

Experimenting with composition: Many artists make a series of small drawings, or 'thumbnails', which serve to explore the possibilities of various compositions, identifying and solving any visual problems in the process.

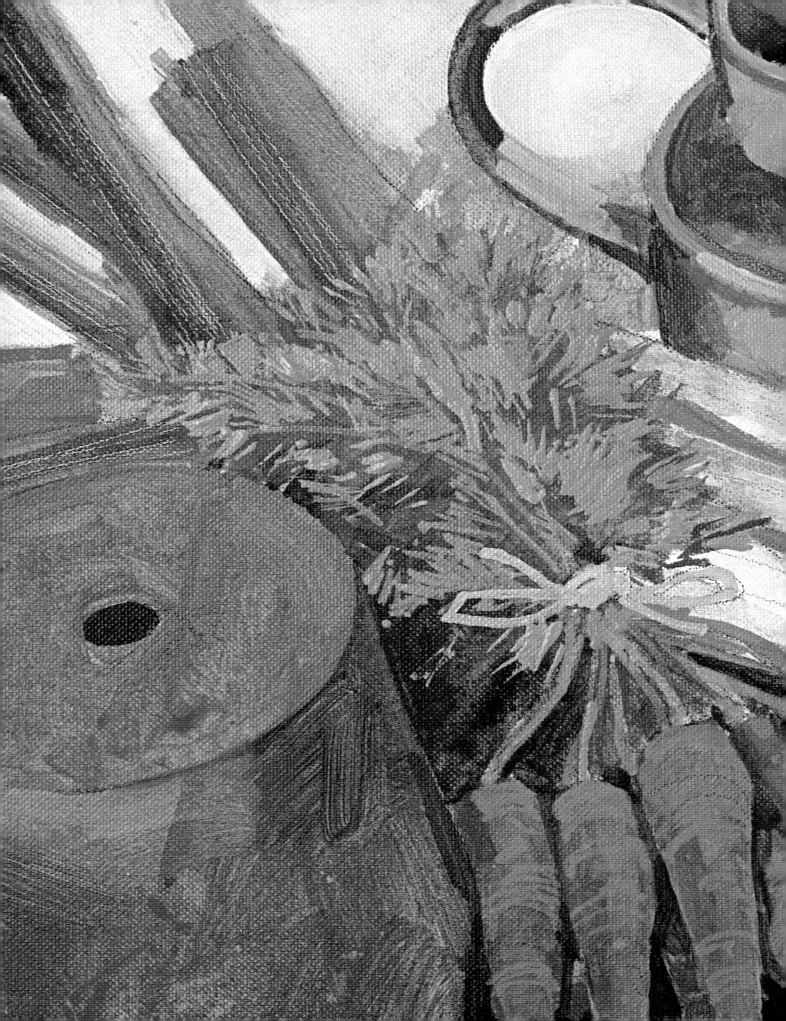

Step 10
bringing it all together

focus: garden tools and vegetables

Materials

60 x 75 cm (24 x 30 in) prepared
 canvas board

Hard charcoal pencil

Fixative

Matte acrylic painting medium

6 mm (¼ in) flat bristle brush

3 mm (⅛ in) flat synthetic-fibre brush

6 mm (¼ in) flat synthetic-fibre brush

12 mm (½ in) flat synthetic-fibre brush

Medium-sized rigger brush

Masking tape

Small trowel-shaped painting knife

Spatula-shaped painting knife
 with angled end

2B graphite pencil

The palette:

- *Titanium white*
- *Quinacridone red*
- *Cadmium red*
 medium
- *Cadmium yellow*
 medium
- *Ultramarine blue*
- *Pthalocyanine green*
- *Dioxazine purple*
- *Raw umber*
- *Burnt umber*
- *Yellow ochre*
- *Mars black*

A number of the techniques used in the previous nine steps are brought together in this painting of vegetables and gardening paraphernalia. Colour mixing and paint handling are the two main areas of focus. However, you will also use a few techniques that create texture and will apply the paint with various tools other than a brush.

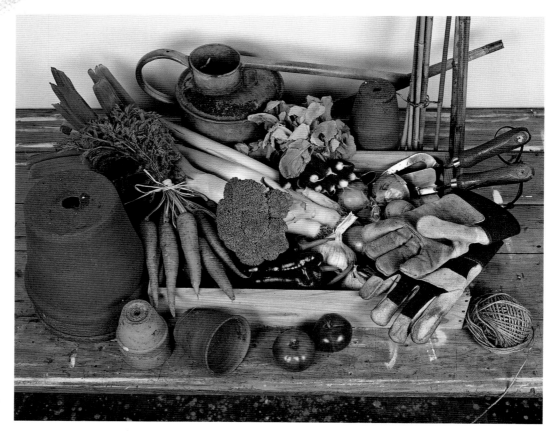

Stage 1: Underpainting the composition

1 Begin by using the hard charcoal pencil to sketch in the main elements of the composition. Use light fluid strokes, holding the pencil a distance away from the point to prevent you applying too much pressure.

2 Having established the relative positions of the main compositional elements, rework the drawing, adjusting the various shapes and forms and adding moderate detail. Do not overdo the detail, however, as this can inhibit your brushwork and seduce you into simply filling in the shapes with paint rather than using the drawing as a guide.

3 The completed drawing should contain just enough information to act as a guide on which to build the painting. If you wish, give the finished drawing a coat of fixative to prevent the charcoal dust mixing with subsequent layers of paint.

4 Using the 6 mm (¼ in) bristle brush begin the underpainting, mixing the paint to a relatively thin consistency using water and the matte painting medium. Try to avoid a heavy build-up of paint in the initial stages. Combine raw umber, yellow ochre and cadmium red to provide a range of terracotta hues for the flowerpots. Mix a dull orange by adding cadmium red and cadmium yellow to the terracotta mix. Use this to block in the carrots.

5 Mix cadmium red and quinacridone red to produce a deep red for the base colour of the peppers and the bunch of radishes. Add a little raw umber to this red to subdue it slightly and use this to paint in the red trim of the gloves.

6 Mix yellow ochre with a little raw umber and use this to paint in the bamboo canes. Add a little burnt umber to warm up the mix and use this to establish the colour of the onions and the handles of both the trowel and the hand fork.

7 Now focus on the greens. Mix a mid-green using a little pthalocyanine green and cadmium yellow. Subdue this with a little yellow ochre and paint in the foliage of the carrots. Add a little ultramarine blue and a little titanium white for the deeper green of the leek foliage, and add a little more yellow ochre and titanium white for the greens of the radish foliage. Add ultramarine blue and more titanium white to create a light blue-green for the head of the broccoli.

8 Use a simple mix of mars black and titanium white to paint the greys of the gloves and the watering can.

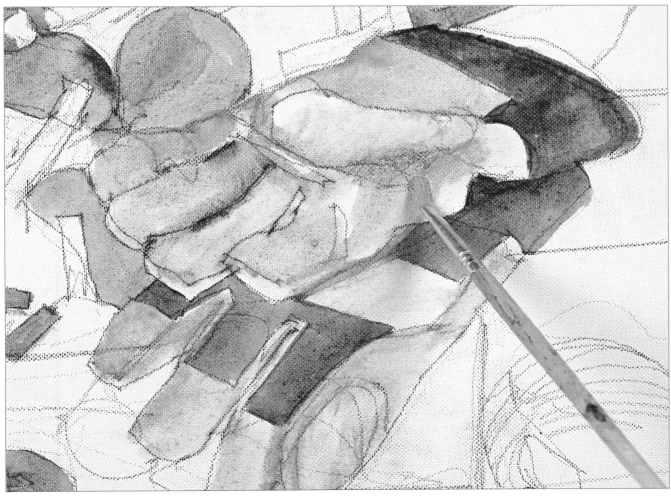

9 Paint the tabletop using a mix made from raw umber and yellow ochre. You can also scrub a little of this mix onto the gardening gloves. Darken the mix by adding more raw umber and a little mars black, and block in the dark area beneath the table. Paint the box containing the vegetables with a mix made from yellow ochre and white.

10 Brush a light grey, made from mars black and titanium white, into the area at the top of the picture to complete the underpainting. You have now established the overall colours of the painting, providing a good base for the subsequent, thicker layers of paint.

Stage 2: Consolidating the colours

11 You can now begin to strengthen and consolidate the colours using paint that is thicker in consistency and more opaque. Using the 6 mm (¼ in) synthetic-fibre brush, begin with the flowerpots and a range of terracotta mixes. First mix a rich terracotta colour using yellow ochre, raw umber and a little cadmium red, then lighten the mix by adding titanium white and cadmium yellow and darken it using raw umber and dioxazine purple.

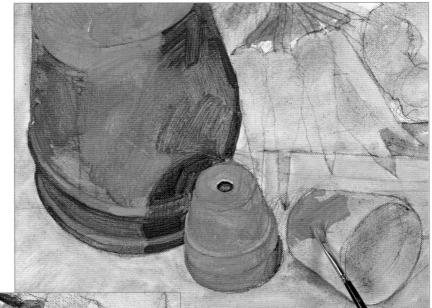

12 Use the darker terracotta mixes in the shadows between and around the carrots. You can then paint the main carrot shapes using a stronger orange mixed from cadmium red and cadmium yellow.

13 Mix together cadmium red and quinacridone red and rework the peppers. Paint around the highlighted areas, leaving the underpainting to show through. Paint the short stalks of the peppers using a bright green made from pthalocyanine green and cadmium yellow, subdued by adding a little yellow ochre.

14 Use the same red mix to consolidate the colour of the tomatoes, adding cadmium yellow to lighten the mix and make it more orange as required.

15 You can use the same red mix as a base for the radishes – darken the colour with raw umber for those areas in shadow. For the slightly washed-out colour of the radish leaves create a good mid-green by mixing together pthalocyanine green and cadmium yellow. Cool the mix down by adding a little ultramarine blue and lighten it using titanium white and a little more cadmium yellow. Darken the mix for the shadow areas by adding a little cadmium red.

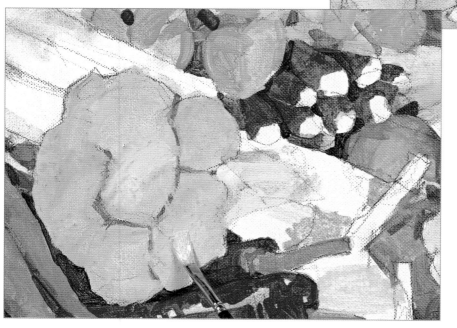

16 Add a little more ultramarine blue to the green mix used for the radish leaves together with titanium white and use the resulting blue-green for the head of broccoli. Add raw umber and mars black for the darker green mix.

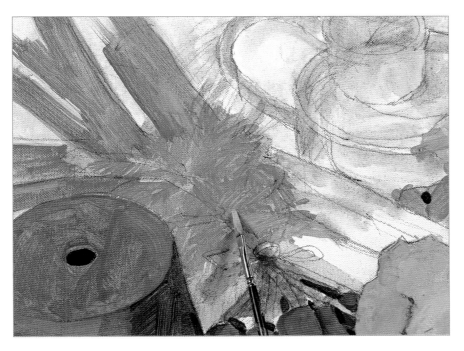

17 Make a deeper green for the leaves of the leeks by adding more ultramarine blue to the green mix used for the radish leaves. Apply using the 6 mm (¼ in) bristle brush, leaving linear marks to represent the texture of the leaves. Make this green brighter and more acidic by adding cadmium yellow and a little more pthalocyanine green. Using the 6 mm (¼ in) synthetic-fibre brush, repaint the carrot foliage making thin linear strokes with the side of the brush.

18 Return to the gloves, repainting the trim using a mix made from cadmium red with a little quinacridone red and raw umber. Now mix the darker greys, which you make using mars black and raw umber with the addition of titanium white. Once you have repainted the darks, lighten the colour with more titanium white and block in the lighter tones.

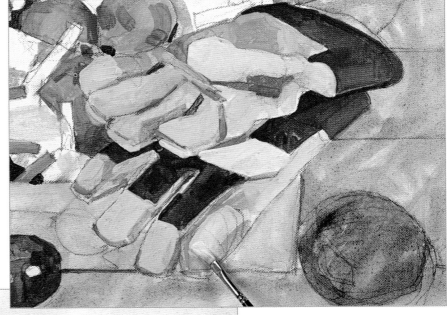

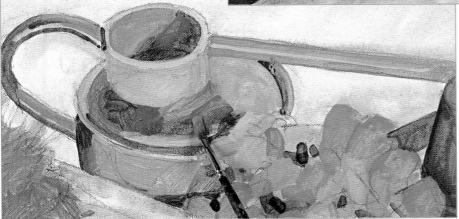

19 Add a little dioxazine purple to these grey mixes to achieve the colour of the watering can. Notice the slight green tinge where moss has coloured the galvanized steel surface of the can. Make this colour by adding a little ultramarine blue and yellow ochre to the grey mix.

Stage 3: Developing tone

20 Stand back from your painting. You have strengthened the colours appreciably and the image now begins to exhibit a degree of depth. It is time to focus on the tonal contrast of the painting, adding the darker tones and picking out highlights.

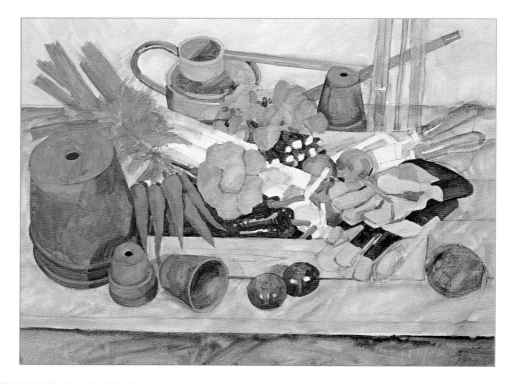

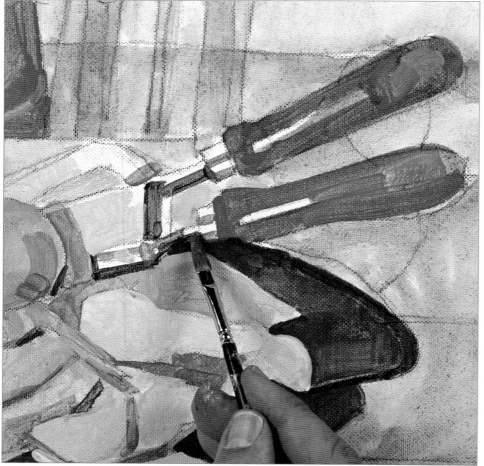

21 Make a raw umber-yellow ochre mix and, still using the 6 mm (¼ in) synthetic-fibre brush, use this mix to repaint the fork and trowel handles. Mix a deep grey from mars black, raw umber and a little titanium white and use this to redefine the dark reflections and shadows on the stainless steel.

22 Repaint the light wall at the top of the picture using titanium white, and the dark beneath the tabletop using a mars black-raw umber mix and the 12 mm (½ in) synthetic-fibre brush.

23 Now repaint the tabletop itself, using mixes based on raw umber, yellow ochre and titanium white with the 12 mm (½ in) flat synthetic-fibre brush. Maintain a crisp edge top and bottom by using masking tape to define the edges. Remove the tape once the paint has been applied.

24 Stand back from your work. See how the tabletop now looks more solid and the illusion of perspective front to back has been increased, which creates depth.

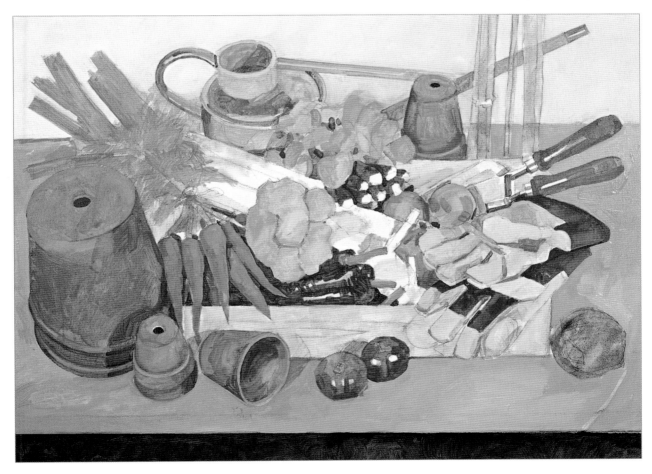

Stage 4: Finishing the painting

25 Repaint the watering can using various combinations of mars black, raw umber, dioxazine purple, ultramarine blue and titanium white. Pay careful attention to the position of the darks on the handle and the spout, and paint these using a 3 mm (⅛ in) synthetic-fibre brush. Mix a green-grey for the body of the can (see step 19) and distribute the colour using your finger to recreate the appearance of its distressed surface.

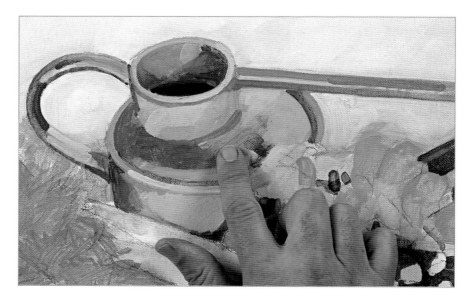

26 Use variations of the same grey mixes to repaint the gloves, still using the smaller brush. Make precise directional strokes to suggest the folds of the fabric, and use the lighter greys to bring out the highlights. Repaint the red trim using the same technique and the colour mixed in step 18.

27 Using a medium-sized rigger brush use the same red on the peppers and the radishes, adding a little titanium white to lighten the colour slightly for the top of each radish. Apply pure titanium white for the very tip of each radish, pulling the thin root out using the point of the brush.

28 Mix a dark green for the leek leaves using pthalocyanine green and cadmium yellow, with a little ultramarine blue and raw umber. Use the 6 mm (¼ in) bristle brush to apply this, and scratch a series of loosely parallel lines through the wet paint using the small trowel-shaped painting knife.

29 Intensify the basic colour of the carrot leaves by loosely scrubbing on a deep green made from pthalocyanine green, cadmium yellow and yellow ochre, using the 6 mm (¼ in) synthetic-fibre brush. Allow this to dry.

30 Lighten the green from the previous step by adding titanium white and use this to paint in the lighter feathery profile of the carrot leaves. Create the strokes using the spatula-shaped painting knife: simply dip the short edge of the knife in the paint and press it to the paint surface in order to create a network of loosely connected linear marks.

31 Rework the carrots to give them more form. Mix a light orange and apply, using the rigger brush, to make a series of linear marks that suggest the form of each carrot.

32 Use light-grey mixes with a little added raw umber to add colour to the cloves of garlic. Still using the rigger brush, rework the broccoli head using a range of blue-greens (see step 16) and short, stippled strokes that suggest the rough texture of the vegetable.

33 Paint the ball of string in three simple steps. Mix a mid-ochre-brown to match the colour of the string, using raw umber, yellow ochre and white and use the rigger brush to paint in the strands of string as they curve around and across the ball. Allow this to dry. Add more raw umber and a little mars black to the same brown and paint in the darks between the strands and at the centre. Finally, lighten the mix using white and paint in the lights.

34 Mix a light brown-ochre from burnt umber, raw umber, yellow ochre and titanium white. Use this colour to paint in a series of horizontal lines on the tabletop to represent the grain of the wood. Use the dark brown from step 33 to suggest the dark spaces between the lengths of wood.

35 Using the 6 mm (¼ in) synthetic-fibre brush, add titanium white to the ends of the leeks and also as highlights on the surface of the bulbs of garlic.

36 Finally add a few lines of sharp 2B pencil to suggest the wood grain on the side of the wooden box and to help capture the form of the two garlic bulbs.

37 The finished image has a lively character that is helped by the straightforward, unfussed brushwork that is in character with the subject matter. The obvious brushmarks are used to very good effect in describing the different surface characteristics and textures of the various elements.

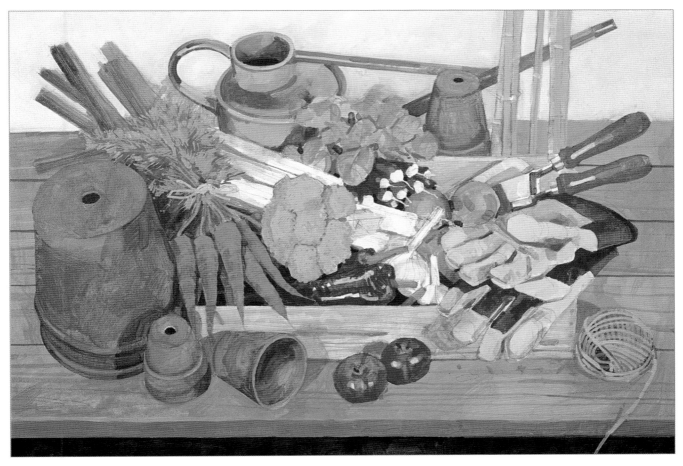

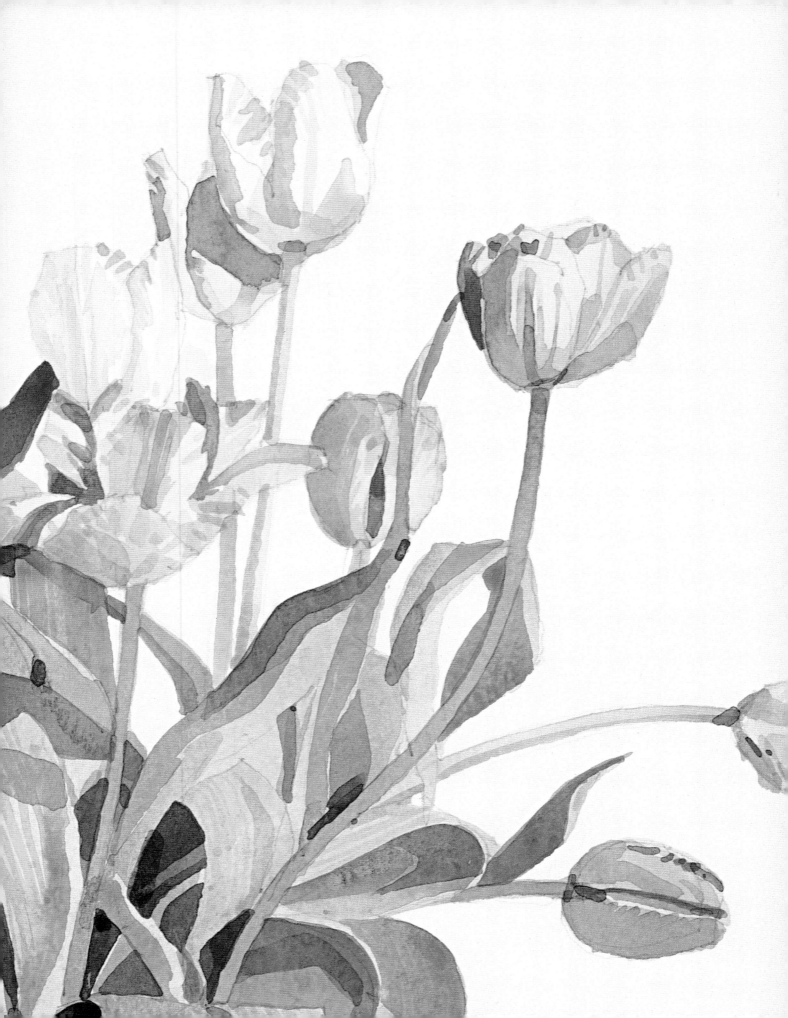

taking it a step further
tulips and landscape

focus: tulips

Materials

55 x 75 cm (22 x 30 in) sheet of
638 gsm (300 lb) NOT surface
watercolour paper

2B graphite pencil

Scrap watercolour paper

Medium-sized rigger brush

Medium-sized watercolour wash brush

The palette:

- *Quinacridone red*
- *Cadmium red medium*
- *Lemon yellow*
- *Ultramarine blue*
- *Pthalocyanine green*
- *Dioxazine purple*
- *Raw umber*
- *Yellow ochre*
- *Mars black*

Thin paint techniques that use acrylic as watercolour are ideal for capturing the delicate forms and colours of flowers. A relatively limited range of colours is used with water and soft brushes. Make sure your mixes are transparent before you apply them to the painting by testing them on a sheet of paper first. As with true watercolour, the white of the paper combines together with the transparent washes to create a full range of tones and colours.

Stage 1: Establishing the underdrawing

1 Begin by sketching in the main elements of the composition using the graphite pencil. Work loosely and very lightly: these initial marks need only act as a guide for the drawing proper.

2 Once happy with the composition, you can elaborate on the drawing, carefully assessing the shape and position of each flower in relation to its neighbour. Work from top to bottom of the image, drawing in the shape of each leaf and carefully adding the crisscross pattern of lines that make up the chequered tablecloth.

3 The finished drawing should be just visible, with the pencil lines light enough that they will not read through the lighter, transparent washes of colour to follow.

Stage 2: The first washes

4 For this technique, you need to apply the paint so that the light colours go on first and the darker, stronger colours last of all. Mix your initial washes with plenty of water and test them on a sheet of scrap paper before applying them to the painting itself. Using the rigger brush, mix lemon yellow with a tiny amount of quinacridone red and plenty of water to create a pale yellow that you use as the base colour for the parrot tulips.

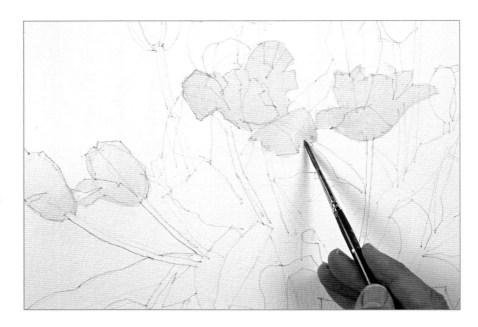

5 Add a tiny amount of raw umber to this pale yellow, to subdue the colour, and use this to paint in the mid tones seen on the pale tulips that stand above the parrot tulips.

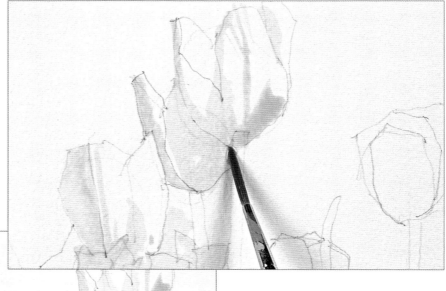

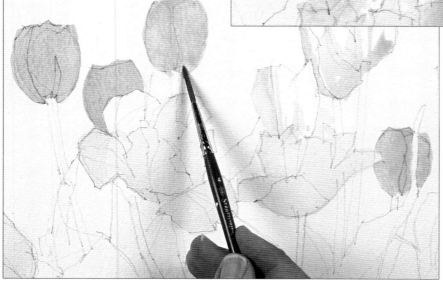

6 Make a light, bright-orange mix using lemon yellow and quinacridone red and apply to the orange tulips.

7 Now mix a pale purple using dioxazine purple and plenty of water and use this to apply a wash over the purple tulips. Leave the whole painting to dry.

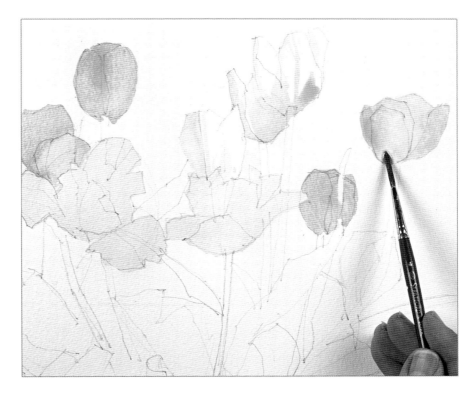

8 Mix pthalocyanine green, lemon yellow and a little yellow ochre with plenty of water to create a mid-green wash. Use a small amount of ultramarine blue to subdue the colour if it seems too bright. Carefully apply this green wash to the leaves and stems of the flowers. If you are right-handed work from left to right across the painting, and vice versa.

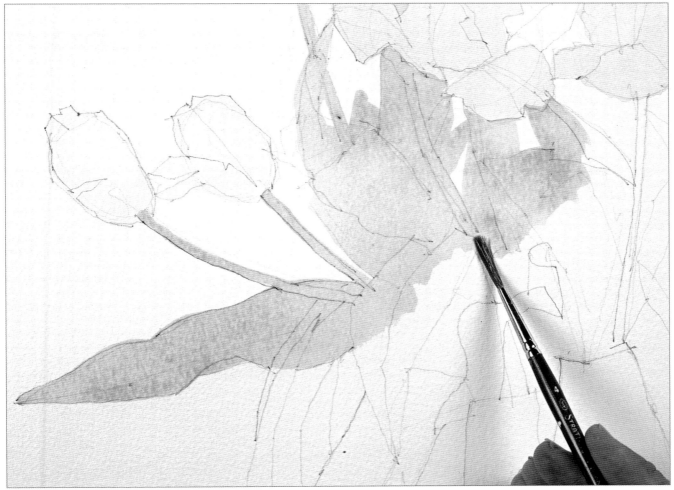

9 Continue the mid-green wash across the entire painting, allowing the paint to puddle at the ends of the leaves at the bottom of the image by tilting the support slightly.

10 Allow the image to dry. You can accelerate the process by using a hair dryer, but be careful not to blow the fluid paint onto areas of the image where it is not wanted.

11 Once the green is dry, mix a range of blue-greys using ultramarine blue, raw umber and a little mars black. Use these to suggest the reflections in the base of the clear glass vase.

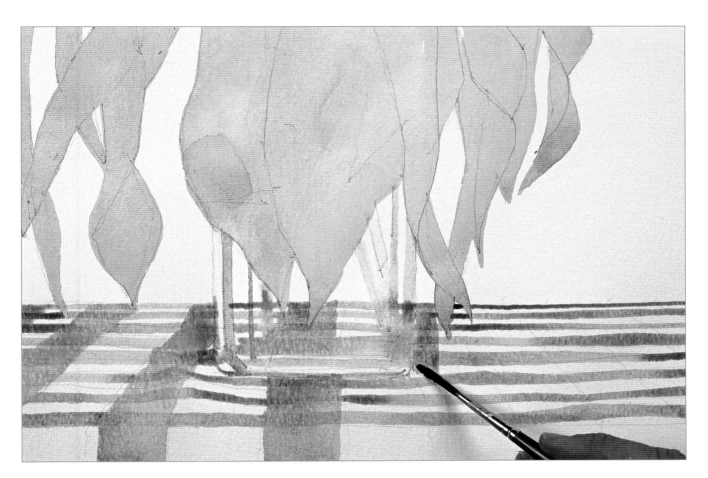

12 Add more ultramarine blue and mars black to this mix for the blue-grey colour of the chequered pattern on the tablecloth. Pay careful attention to perspective, here, as it gives the image its sense of depth.

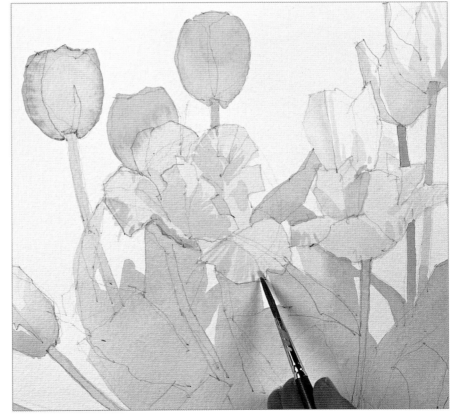

13 Turn your attention back to the flowers. Lighten the green used in the foliage (see step 8) by adding more lemon yellow and plenty of water. Use this to paint in the green blush on the parrot tulips to the extreme left and right of the painting. Mix a deeper, orange-yellow for the mid tones on the parrot tulips at the centre of the image.

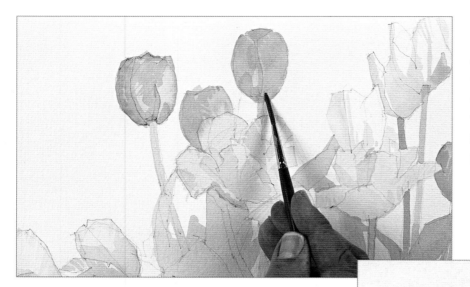

14 Strengthen the colour of the orange tulips with a bright-orange mix made from quinacridone red, lemon yellow and a little yellow ochre. Work carefully around the lighter tones and use a few brushstrokes to suggest the barely noticeable linear pattern on the petals.

15 Repeat the process on the light pink and purple flowers using pink mixes made using quinacridone red, a little lemon yellow and plenty of water, and the same purple mixes you made in step 7.

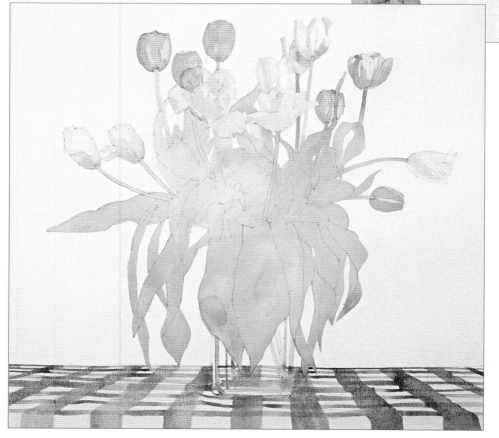

16 Stand back from your painting. The various species of tulip have begun to take on their own individual identity. The colours are still very pale, but you have established the basis for darker, more intense, applications of colour.

Stage 3: Building up colour and detail

17 Mix a strong, deep green using pthalocyanine green, lemon yellow and yellow ochre with plenty of water. As you work, modify this colour by adding various amounts of ultramarine blue and cadmium red. Begin by painting the stems of the flowers. Once painted, add a little clean water to the end of the stem at the point where it joins the flower head. Tilt the painting and watch as the water pushes into the paint, creating a graded tone effect down the length of the stem. Paint each leaf carefully, allowing the paint to puddle in those areas where colour and tone are darkest.

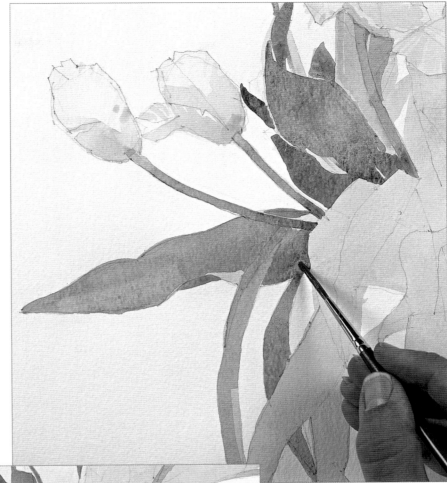

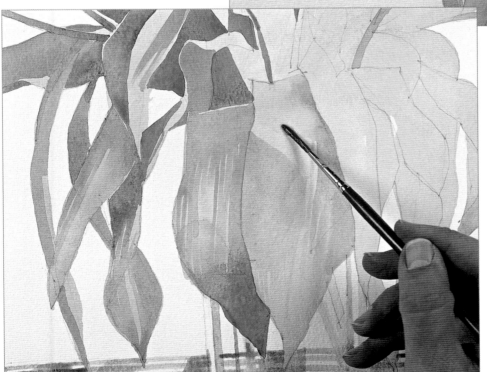

18 Continue to work across the image, altering the tone of your green mix as you work simply by adding water. Work slowly and strive to allow each leaf to keep its identity even when it appears to merge with another.

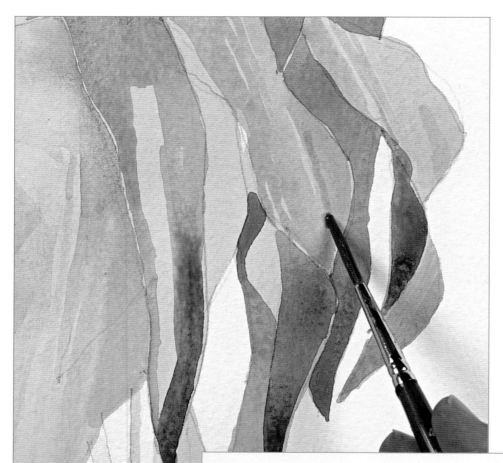

19 As you work, introduce some of the linear pattern that can be seen running the length of each leaf and continue to let the paint puddle in those areas where the colour or tone is darkest.

20 Look at your work. The foliage now begins to have some depth with leaves coming forward or receding in space. This effect will become even more apparent when stronger, deeper darks are introduced, which will increase the tonal contrast and make the lights appear brighter.

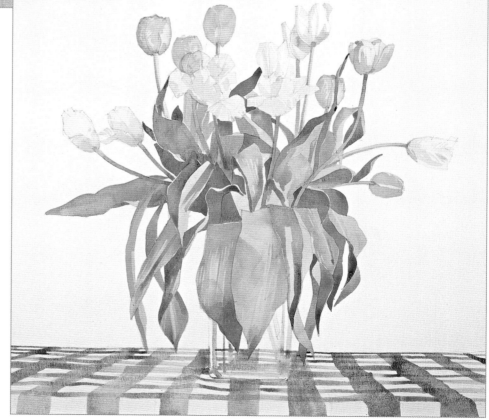

Stage 4: Developing tone and perspective

21 Mix some dark greys using mars black, raw umber and a little ultramarine blue and use these to repaint the crisp reflections seen in the glass base of the vase. Use the same dark mix to paint in the darker squares on the patterned cloth.

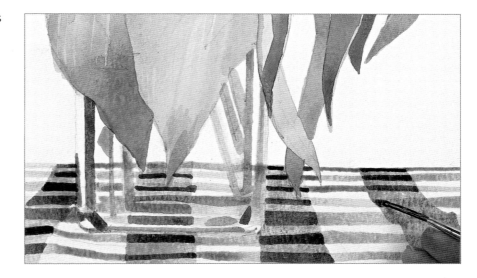

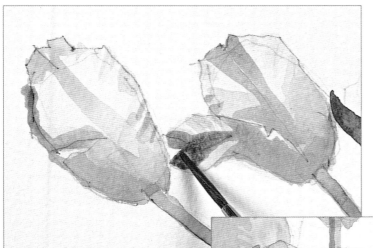

22 You can now start to add detail and pattern to the flower heads. Mix quinacridone red and a little cadmium yellow with plenty of water for the colour on the parrot-tulip petals. Use a light-green mix at the base of the flower (see step 13) and introduce the red mix so that the two colours run together.

23 Apply the same technique to the central parrot tulips. Allow the red mix and more orange mixes (see step 14) to run together, wet into wet, to create the soft transition from one colour to the next.

24 Repeat the process for the orange tulips, dropping clean water into the orange mix to lighten it and raw umber to the areas that puddle to darken it.

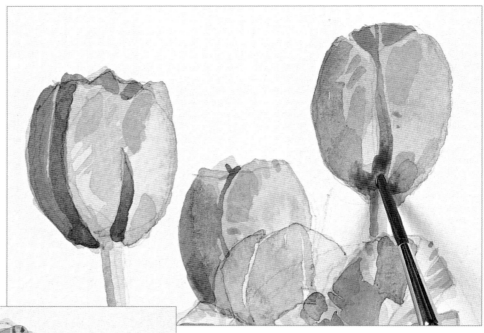

25 Work in the same way on the purple tulips, dropping a green mix into the purple washes to suggest the slight green bloom seen at the base of each flower.

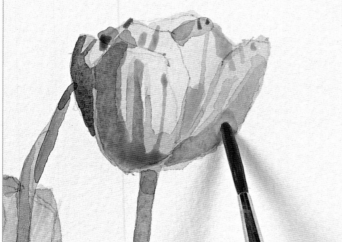

26 Finally, paint the pink flowers using mixes made from quinacridone red and lemon yellow with a little added dioxazine purple for the shadow areas.

27 Using greens similar to those mixed for step 17, paint the linear marks that run the length of the leaves. Try to get the direction of these lines right, as they help suggest the shape and position of each leaf.

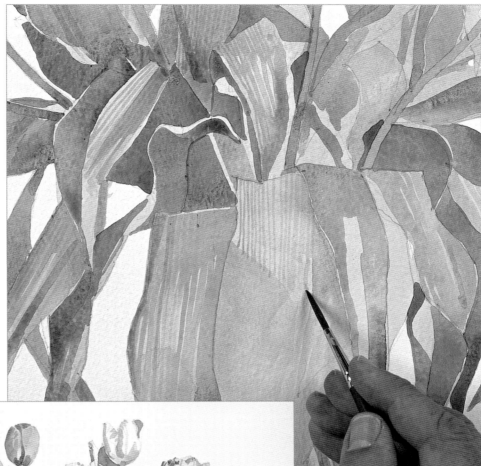

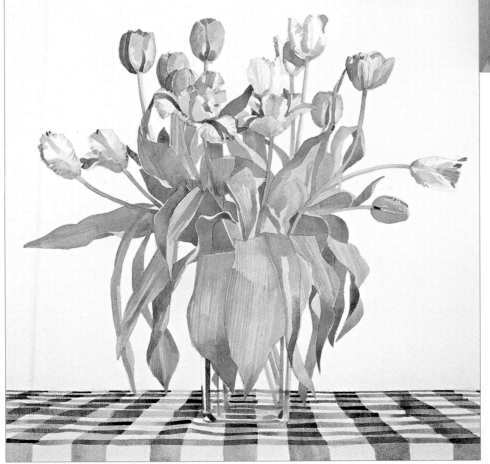

28 Stand back from your painting once more. The introduction of darker, more intense colours, has increased the sense of perspective.

Stage 5: Finishing the painting

29 Increase the feeling of depth further by introducing a dark-green wash, made from pthalocyanine green and cadmium yellow with the addition of raw umber and mars black. Intensify the depth of colour in the darkest areas by allowing the paint to puddle. Allow the paint to dry naturally.

30 Watermarks left as the paint dries should be viewed as a bonus: they add both texture and interest. Distress the leaves slightly by spattering light green onto them. Load the brush with paint, hold it above the image surface and tap it smartly with your index finger.

31 Now add the brightest, most intense colour washes to the flower heads and any darks deep within the recesses of the petals.

32 Mix up a very pale light grey from mars black with a little added ultramarine blue and use the watercolour wash brush to paint in the shadow cast by the flowers onto the wall. Use the rigger brush to paint this wash into the smaller spaces between the leaves. Darken this mix slightly using more ultramarine blue, and paint in the shadow that is cast across the cloth.

33 Watercolour techniques are ideal for this subject matter, as they make it easy to mix the subtle colour variations demanded. Working light to dark keeps you in control of the image even though, unlike traditional watercolour painting, it is impossible to remove any paint or subdue colours by re-wetting.

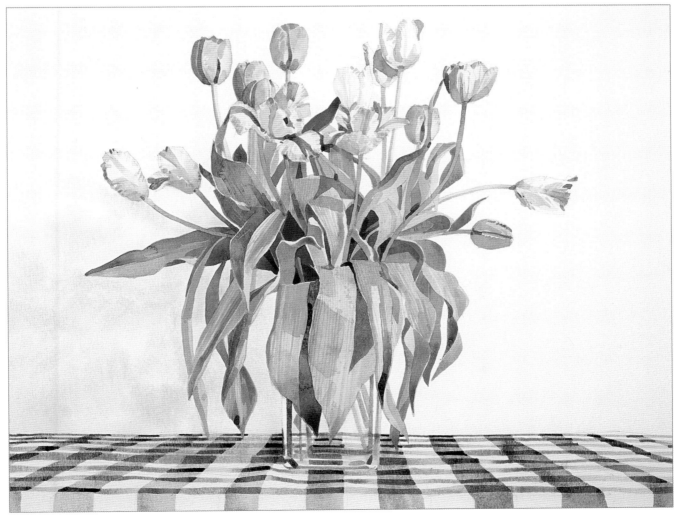

focus: landscape

Materials

50 x 60 cm (20 x 24 in) prepared
 canvas board

Hard charcoal pencil

Fixative

Matte acrylic painting medium

18 mm (¾ in) flat bristle brush

6 mm (¼ in) flat bristle brush.

3 mm (⅛ in) flat synthetic-fibre brush

6 mm (¼ in) flat synthetic-fibre brush

Medium-sized rigger brush

2B graphite pencil

Natural sponge

Small trowel-shaped painting knife

Natural sand
 texture paste

The palette:

- *Titanium white*
- *Cadmium yellow*
 medium
- *Ultramarine blue*
- *Pthalocyanine blue*
- *Pthalocyanine green*
- *Raw umber*
- *Burnt umber*
- *Yellow ochre*
- *Mars black*

Thick paint techniques are explored further in this painting of an old oak tree. The skeletal network of branches presents a particular set of problems. Again the work is executed in layers, with thin applications of paint used in the underpainting and thicker applications of paint used in the top layers. The technique of sgraffito is put to good use, as is the painting knife to capture the texture of the trunk.

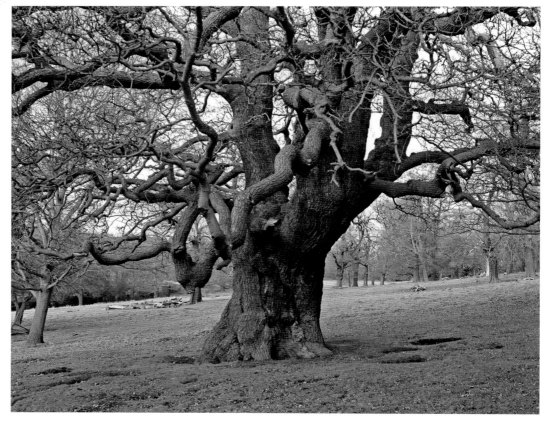

Stage 1: Establishing the underpainting

1 Use the charcoal pencil to sketch in the composition loosely, using just a few basic lines. Position the tree centrally, its tangled branches stretching to the extremes of the paint surface left and right.

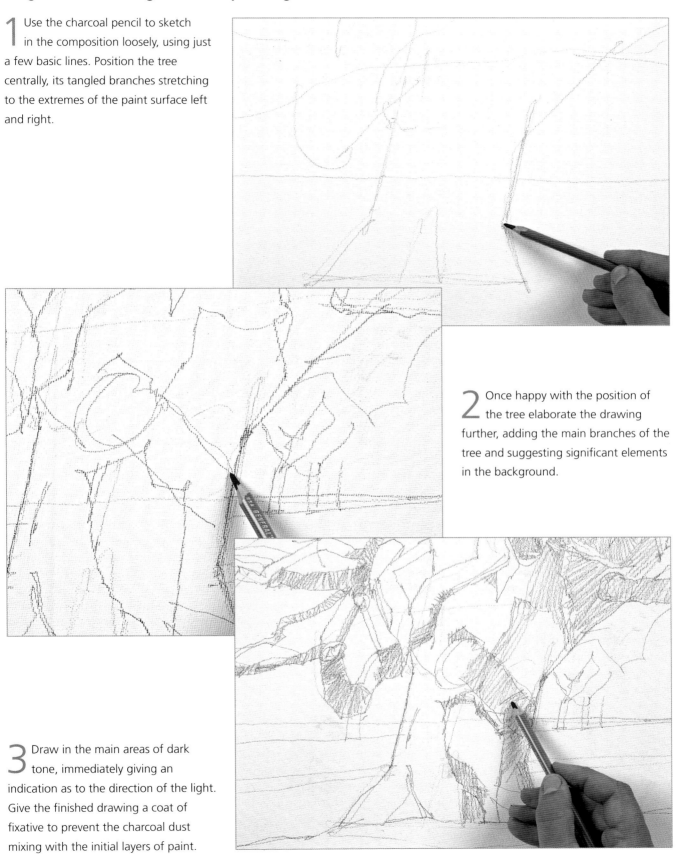

2 Once happy with the position of the tree elaborate the drawing further, adding the main branches of the tree and suggesting significant elements in the background.

3 Draw in the main areas of dark tone, immediately giving an indication as to the direction of the light. Give the finished drawing a coat of fixative to prevent the charcoal dust mixing with the initial layers of paint.

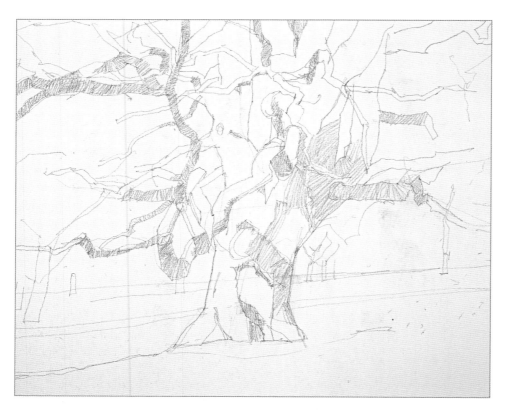

4 Stand back from your drawing. Notice how the old tree dominates the image, and yet the angle of the main trunk and the jumbled, irregular configuration of branches allows for the subject to be positioned centrally. This is a good example of how compositional rules can be broken successfully.

5 Keep the initial applications of paint relatively thin, mixing them with plenty of water and painting medium. Begin by mixing a light blue using ultramarine blue, a little pthalocyanine blue and titanium white. Use the 18 mm (¾ in) bristle brush to block in the sky area loosely.

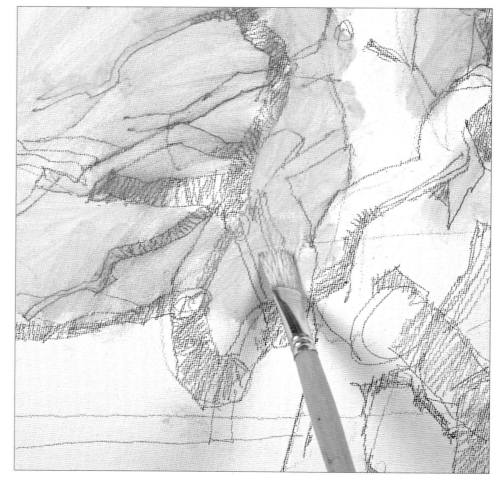

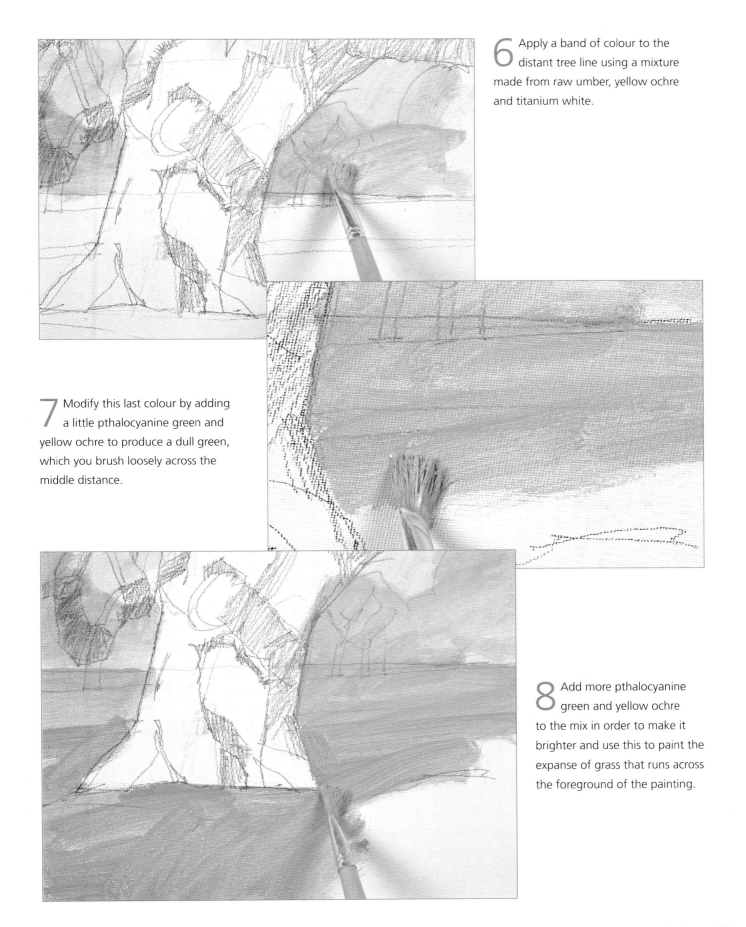

6 Apply a band of colour to the distant tree line using a mixture made from raw umber, yellow ochre and titanium white.

7 Modify this last colour by adding a little pthalocyanine green and yellow ochre to produce a dull green, which you brush loosely across the middle distance.

8 Add more pthalocyanine green and yellow ochre to the mix in order to make it brighter and use this to paint the expanse of grass that runs across the foreground of the painting.

9 Switch to the 6 mm (¼ in) bristle brush and mix a dull brown using raw umber, a little yellow ochre and titanium white. Use this to establish the basic colour of the tree itself.

10 Stand back from your painting. You have completed the underpainting, applying basic colour very loosely, and providing a good base on which to build the work further.

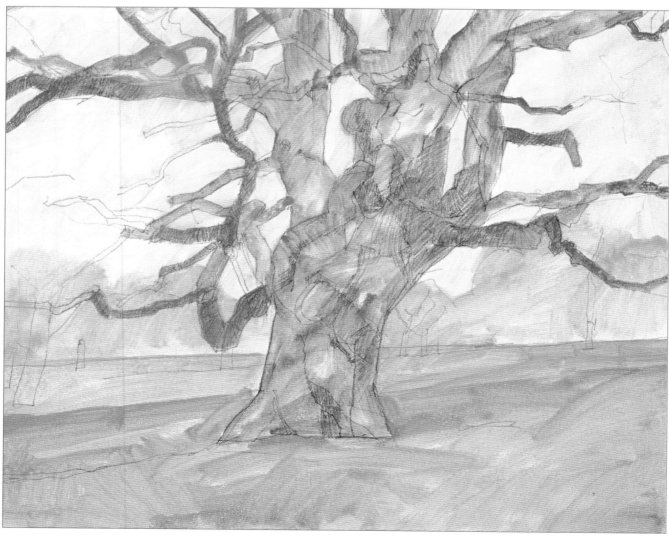

Stage 2: Building perspective

11 Mix a pale grey-brown using raw umber, yellow ochre and ultramarine blue. Lighten the colour with titanium white and repaint the band of trees and shrubbery that runs horizontally across the image. As you work, and while the paint is still sufficiently wet, use the wooden end of the paintbrush to scratch into the wet paint creating a series of marks that represent the lighter trunks and branches.

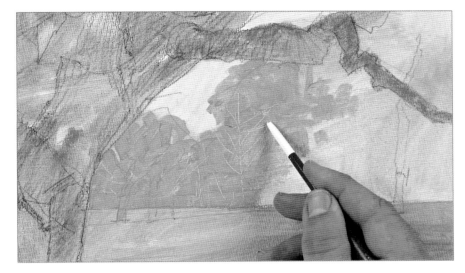

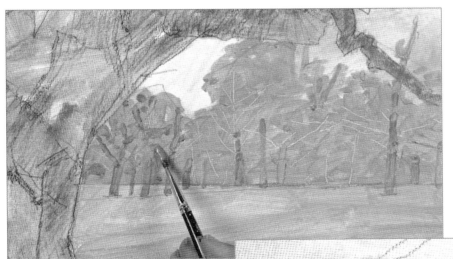

12 Add a little burnt umber to this last mix and, using the 3 mm (⅛ in) synthetic-fibre brush, suggest a few of the more obvious trees and main branches with a few simple strokes and dabs of colour.

13 Darken the same brown mix further by adding raw umber and paint in the darker area beneath the trees. Add a little pthalocyanine green and yellow ochre to this mix and, using simple dabs and short brushstrokes, paint in the tree foliage. Keep the tone of these colours very similar in order to enhance the effect of aerial perspective – that is, so that the detail of the trees seen in the background is less distinct than that of the tree in the foreground.

14 Add a little more yellow ochre and titanium white to the previous mix in order to create a light straw colour. Use this to paint the band of dry grass running beneath the trees. Paint carefully around the trunks of those trees that are growing out of the ground here.

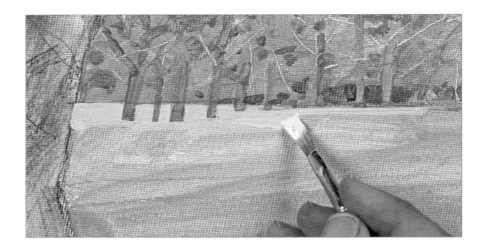

15 Use any of the above mix that is left over and mix in raw umber and a little yellow ochre to create a brown for painting the bare patches of earth showing through the grass. Mix in a little pthalocyanine green, cadmium yellow and yellow ochre to create a dull green. Paint this colour across the foreground of the picture using the 6 mm (¼ in) bristle brush.

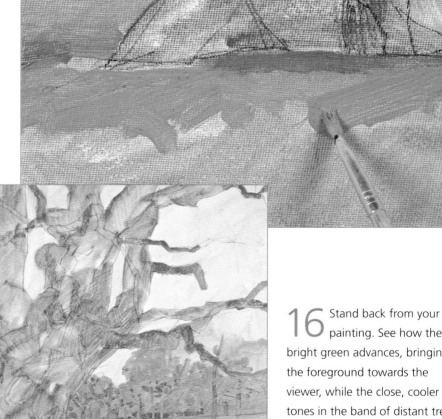

16 Stand back from your painting. See how the bright green advances, bringing the foreground towards the viewer, while the close, cooler tones in the band of distant trees pushes them into the distance.

Stage 3: Consolidating the colour

17 Mix a mid-brown using raw umber, a little burnt umber and a little mars black. Use both the 3 mm (⅛ in) and 6 mm (¼ in) synthetic-fibre brushes to start painting the main branches of the tree. Use a combination of fluid and jerky brushstrokes that abruptly change direction in order to capture the way in which the branches have grown.

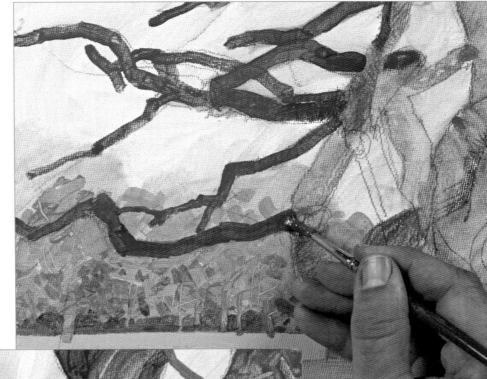

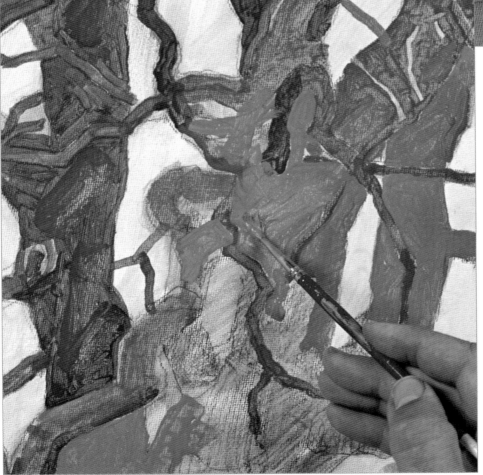

18 Adjust and lighten the mid-brown by adding a little more titanium white and yellow ochre, and use this colour to consolidate the larger of the lighter branches and trunk. Paint around any lighter branches that cut across the main trunk.

19 Darken the brown used in step 18 by adding raw umber and a little ultramarine blue and paint in those parts of the tree that are in shadow.

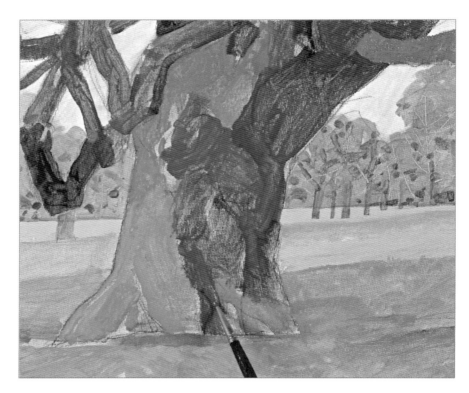

20 Many of the branches are dull green in colour. Mix this by adding a little pthalocyanine green into the dark-brown mix. Use the rigger brush to paint the finer branches.

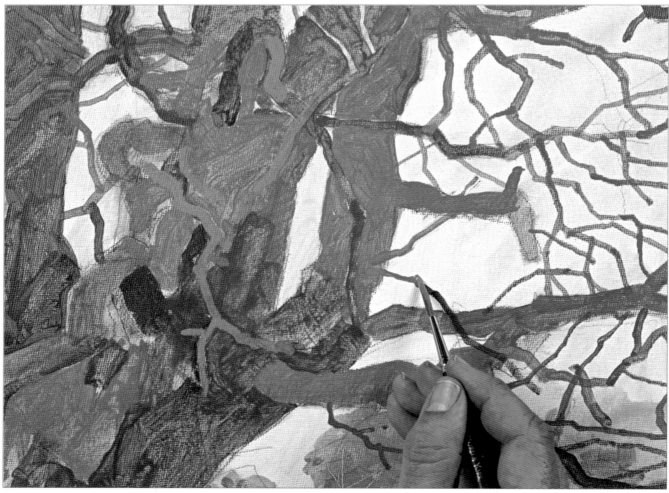

21 Develop the trees on the left of the image next. Use the same browns as those you mixed for the main tree, making them slightly lighter by adding titanium white. Use the rigger brush to pull the network of fine branches up to cut across the sky.

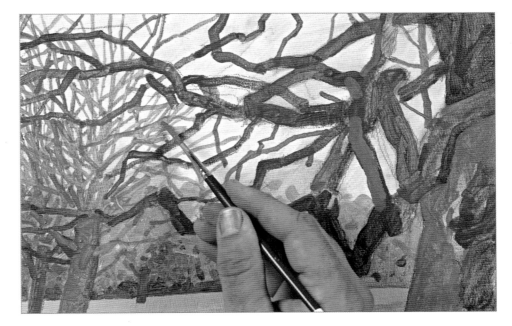

22 Use the dark brown used on the main tree (see step 19) to consolidate the shadows beneath the distant trees and to redefine those tree trunks and branches in shadow.

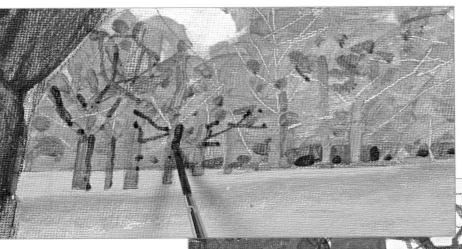

23 Rework the network of branches, using the 2B pencil to draw in the finer twigs.

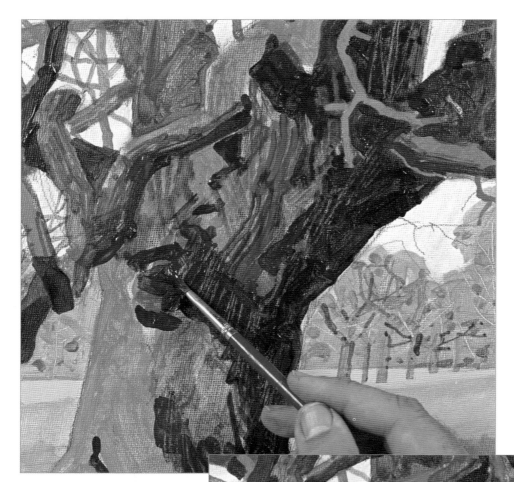

24 Mix a very dark brown using burnt umber, ultramarine blue and mars black, and apply this carefully to those areas of the main tree that are in shadow. Use the 3 mm (⅛ in) fibre brush to cut around the branches that are lighter in tone. As you work, periodically use the pointed handle of the brush to scratch through the paint to suggest the texture of the bark.

25 Lighten this last mix slightly with titanium white and warm it up by adding more burnt umber and yellow ochre. Use this colour and the rigger brush to repaint the mid tones and bark textures using a series of fine lines.

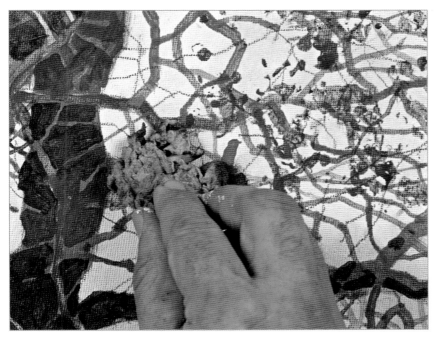

26 Take what is left of the brown mix and add water so that it is relatively fluid. Using a small piece of a natural sponge, apply dabs of colour across the area of branches, taking care not to overdo the effect. Turn the sponge as you work so that each time you apply it to the image the resulting pattern is different.

27 Stand back from your painting. Notice how the addition of the sponge marks has the effect of breaking up the pattern of branches and represents dried leaves and small twigs left on the tree at the end of winter.

Stage 4: Finishing the painting

28 Mix a light blue using ultramarine blue, a little pthalocyanine blue and titanium white. Using the rigger brush, repaint the sky, carefully working around and between the branches. Although this is time-consuming, this gives you the chance to redraw the shape and configuration of the branches.

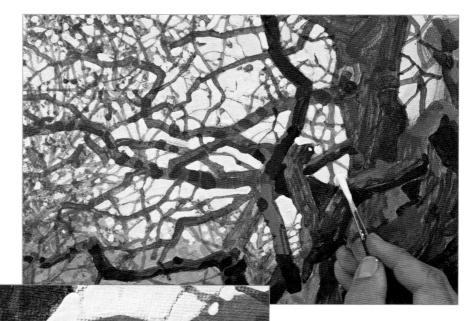

29 Use the same light-blue mix to paint into, and break up, the outline of the band of trees in the distance.

30 Mix a light brown from raw umber and yellow ochre lightened with titanium white, and use to paint in a series of fine linear marks to represent the pattern of the bark on the light side of the tree.

31 Increase the effect by using the side of the small trowel-shaped painting knife to apply a series of linear marks to the main trunk of the tree.

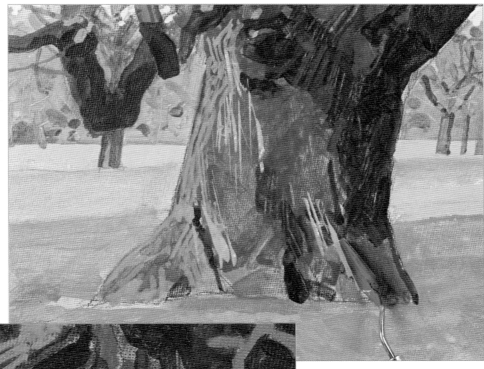

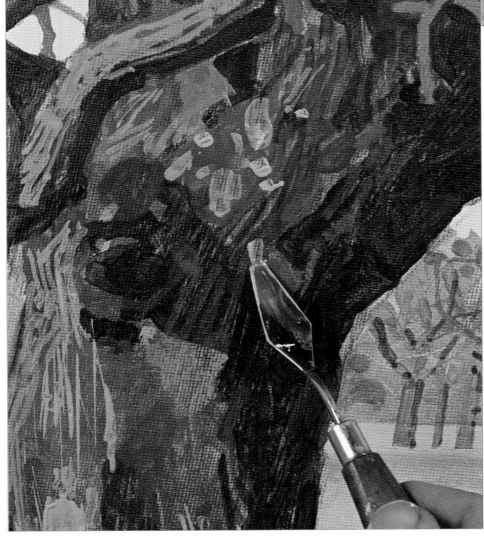

32 Use the very end of the knife to make a series of marks to trunk and branches, representing knots and stumpy broken branches.

33 Use the natural sand texture paste to provide texture to the areas of soil showing through the grass in the foreground. Mix the paste with raw umber, yellow ochre and titanium white and apply loosely using the 6 mm (¼ in) bristle brush so that the brush marks remain evident.

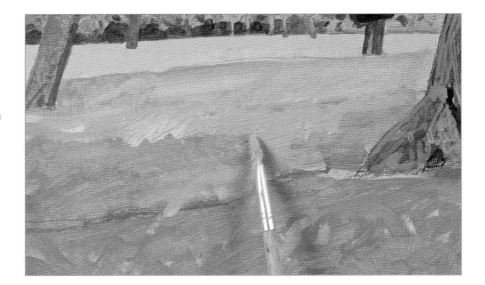

34 Mix a light green using a little pthalocyanine green with yellow ochre and titanium white. Modify this colour by adding a little raw umber and more titanium white, and apply this up to and around the areas of texture, using open strokes. Do not brush the paint out but scratch into it, using the painting knife, to represent the dried stalks of grass.

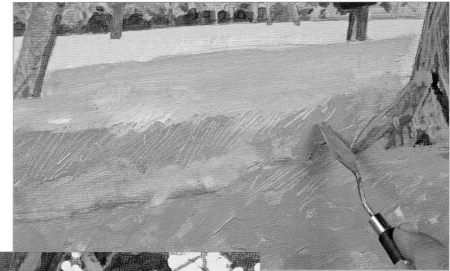

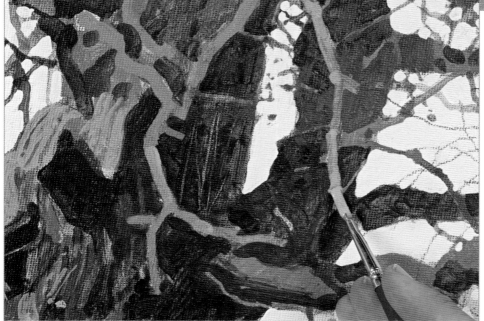

35 Repaint those branches that are green from algae growth with the 3 mm (⅛ in) flat synthetic-fibre brush, adding a few extra branches. Mix a dull green for this from raw umber, yellow ochre, a little pthalocyanine green and titanium white.

36 Finally, make a few scribbled pencil marks on both the tree trunk and the area of grass around the roots to add a little more loose detail.

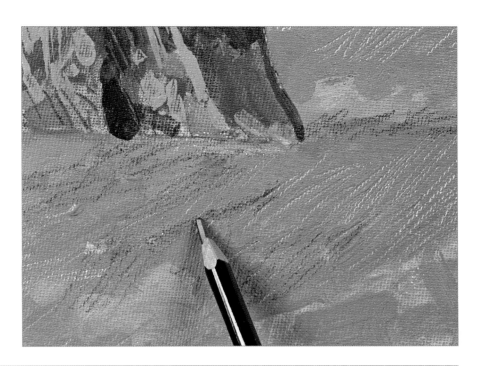

37 A range of mark-making techniques have been used in this painting, capturing the various textures and maintaining a loose and interesting paint surface, which is in keeping with the inherent character of the subject.

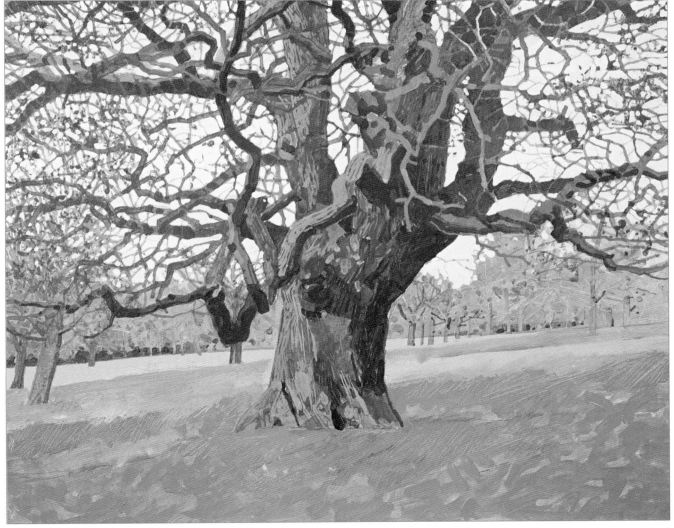

index

ACKNOWLEDGEMENTS

Executive Editor Katy Denny
Editor Leanne Bryan
Design Manager Tokiko Morishima
Designer Peter Gerrish
Production Manager Ian Paton
Photography Colin Bowling and Ian Sidaway

PICTURE ACKNOWLEDGEMENTS

Special Photography: **Octopus Publishing Group Limited/**
Colin Bowling and Ian Sidaway.